Painting **Still Lifes** *In Oil*

 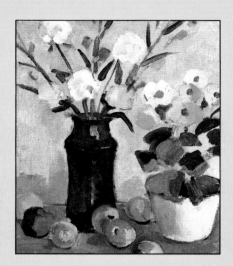

JOSE M. PARRAMON

Watson-Guptill Publications/New York

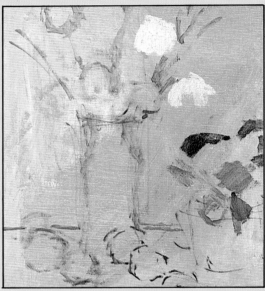

Copyright © 1988 by Parramón Ediciones, S.A.

First published in 1991 in the United States by Watson-Guptill
Publications, a division of BPI Communications, Inc.,
1515 Broadway, New York, New York 10036.

Library of Congress Cataloging-in-Publication Data

Parramón, José María.
 [Pintando bodegón al óleo. English]
 Painting still lifes in oil / José M. Parramón.
 p. cm.—(Watson-Guptill painting library)
 Translation of: Pintando bodegón al óleo.
 ISBN: 0-8230-3864-5
 1. Still-life painting—Technique. I. Title. II. Series.
ND1390. P2913 1991
751.45'435—dc20 90-49245
 CIP

Distributed in the United Kingdom by Phaidon Press, Ltd.

Manufactured in Spain
Legal Deposit: B-35.179-90

1 2 3 4 5 6 7 8 9 / 95 94 93 92 91

Painting Still Lifes *In Oil*

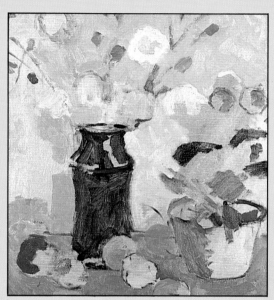

The Watson-Guptill Painting Library is a collection of books that teaches the student of painting and drawing through an examination and detailed explanation of the work of several professional artists. Each volume demonstrates the techniques and procedures required in order to paint in watercolor, acrylic, pastel, colored pencil, oil, and so on—each with a specific theme: landscapes, still lifes, figure painting, portraits, seascapes, and so on. Each book in the series presents an explanatory introduction on that specific discipline followed by step-by-step lessons. In this book, *Still Life Painting in Oil*, we will start by studying in depth the basic norms of composition as well as the differences between valuism and colorism. The techniques, utensils, and materials used in the medium are also reviewed in each volume.

But the most extraordinary aspect of this book is the comprehensive treatment of all the elements of the painting—the choice of theme, the composition, color interpretation and harmonization, the effects of light and shadow, color temperature, and so on. The professional artists featured here pass on their knowledge and experience along with their techniques, secrets, and tricks brushstroke by brushstroke, step by step. Dozens of photographs taken while the artists were painting add to the value of the lessons.

I personally directed this work with a team I am proud of, and I can say that I honestly believe this series of books really teaches you how to paint.

José M. Parramón
Watson-Guptill Painting Library

Van Gogh and His Still Life Paintings

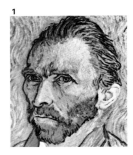

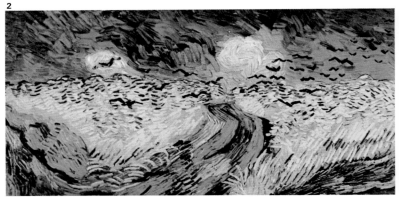

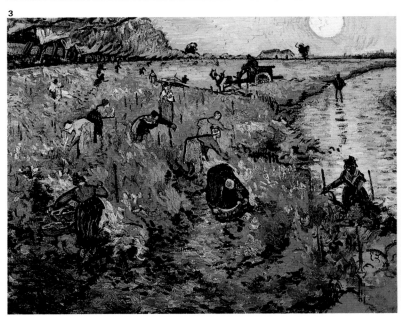

Fig. 1. Vincent van Gogh. *Self-portrait* (detail). Orsay Museum, Paris. In the last years of his life, van Gogh painted around thirty portraits; this is one of the best, painted two years before he committed suicide.

Fig. 2. Vincent van Gogh. *Wheat Field with Crows.* 1890. Stedelijk Museum, Amsterdam. This is the picture van Gogh painted two days before his death on the outskirts of the village of Auvers-sur-Oise, in northern France.

One sunny Sunday during the month of July 1890, near the village of Auvers-sur-Oise in northern France, some farm workers heard a shot and ran to a shed where they found a man with a gunshot wound in his chest and a still-smoking gun in his right hand.

"It's that crazy painter!" exclaimed one of them. "His name's van Gogh. The day before yesterday he was here with his easel, painting this wheat field!" Two days later, on July 29, the mad painter died.

Poor Vincent van Gogh (1853–1890)! He lived and died in poverty, ignored, rejected by society as a mentally unbalanced person, because, among other things, of his way of painting. "I am going crazy with such loneliness and poverty around me," he wrote in a letter to his brother, Theo, a few months before committing suicide. Out of the many hundreds of pictures van Gogh painted during his lifetime, he sold only one: *Red Vineyards in Arles*, which was bought by Anna Boch for 400 francs. It is not known whether she purchased it out of pity for the artist or because she sensed the painting's exceptional value.

If she did sense some greatness in his work, Anna Boch was not mistaken. In the spring of 1987, Sotheby's of London auctioned the van Gogh painting *Sunflowers*; and in the autumn of the same year, Sotheby's of New York auctioned his painting *Lilies*. They were the most expensive paintings ever bought in the history of art at that time. What is more extraordinary is that they are paintings of flowers or still lifes.

Through his paintings, van Gogh started the distortions of *fauvism* and *expressionism*, painting flat forms and violent colors. Van Gogh and Paul Cézanne (1839–1906) were the two great revolutionary forerunners of modern art. Both painted many still life pictures, which they considered to be a studio theme. Cézanne described it thus, "A laboratory experiment to test, combine, compose, by developing visual perception, the art of seeing and composing, the idea of constructing a picture as an integral whole." They both believed the still life was the perfect theme for learning: "... and another thing I could do to make money," van Gogh told his brother Theo, "would be to give drawing classes by starting off with the still life since I believe it is the best model to learn how to paint."

Fig. 3. Vincent van Gogh. *Red Vineyards in Arles.* Pushkin Museum of Fine Arts, Moscow. This is the only painting van Gogh sold during his lifetime. It was bought by Anna Boch for 400 francs.

It is true, as you will see for yourself in the pages of this book as you follow the experts' step-by-step, brushstroke-by-brushstroke instructions on what to do and how to do it. In other words, you will learn how to paint a still life.

But before continuing, allow me to remind you of a few basic facts on form —Cézanne, and color—van Gogh. Let's look at *composition, valuism,* and *colorism.*

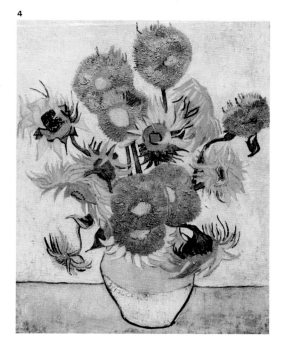

Fig. 4. Vincent van Gogh. *Sunflowers.* Private collection. Van Gogh painted two pictures of sunflowers in the same vase. One of them is in the Tate Gallery in London. The other one, which is reproduced here, was auctioned in 1987 for an enormous sum.

Fig. 5. Vincent van Gogh. *Lilies.* 1889. 28 inches × 37 inches (71 × 93 cm). Private collection. This painting broke all records for being the most expensive painting ever sold in art history to date.

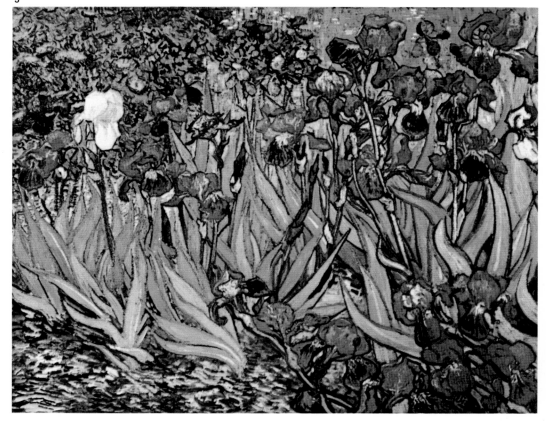

Cézanne's Formula

Paul Cézanne painted more still lifes than any of the other impressionist artists. He was a skinny, introverted man, described by one of his friends as being "terrible and beastly like a disturbed divinity." Cézanne's contemporaries, Georges Seurat (1859–1891), Paul Gaugin (1848–1903), van Gogh, and others, had spoken and written about the physical and optical norms of painting. Cézanne spoke little and wrote even less: "I do not speak, I paint," he said.

He was preoccupied with the form and the structure of bodies. The French art historian, Elie Fauré, wrote in this respect: "To understand Cézanne, you must take into account, before anything else, his preoccupation with the succession of planes. For Cézanne, color was secondary to form." And Cézanne himself said, **"When color gives all its richness, form has achieved all its plenitude."**

Cézanne spoke little, but resuming his vision and synthesis of form during the last years of his life, he repeated once again his famous words on the necessity of reducing the forms of bodies to the shape of a

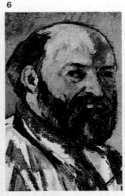

Fig. 6. Paul Cézanne. *Self-portrait.* Orsay Museum, Paris. Among all the impressionists, Cézanne was without doubt the painter who did the most still life paintings. He was not a theoretician, like many other artists of his epoch, but he said on more than one occasion, "the painter must find the sphere, cone, and cylinder in all nature's forms."

cube, sphere, and cylinder, "clearly capturing the laws of perspective for each side or plane of the object it is directed to," wrote his friend Pierre Bonnard (1867–1947).

Cézanne's formula is applicable to any body or subject in general—from a refrigerator to a skyscraper—but it is especially suited for constructing and drawing nature's forms that are a constant in still life paintings—all kinds of fruit, apples, peaches, grapes, and so on. All of them have a sphere shape. Cups, jars, and bottles have a cylindrical shape. Books, tables, chairs, and so on derive from the shape of a cube.

These three forms—the sphere, cylinder, and cube—are ideal for practicing and studying the effects of light and shadow, and for working out the problems of perspective. Try drawing the basic forms that you see at the bottom of these two pages using a soft lead pencil, such as a number 4B or 6B. Draw them from memory placing the objects in different positions. It is a good exercise to ensure a good drawing of the forms.

Fig. 7. I expect that you can draw a cube, cylinder, pyramid, and sphere from memory "clearly capturing," as Cézanne said, "the laws of perspective" and at the same time taking into account the effects of light and shadow. Do it all from memory. I recommend you do this exercise regularly in order to draw better.

Fig. 8. Most objects that you see around you—from a table or chair to a glass or shelf—can be drawn from the basic shapes of a cube, rectangular prism, cylinder, and sphere.

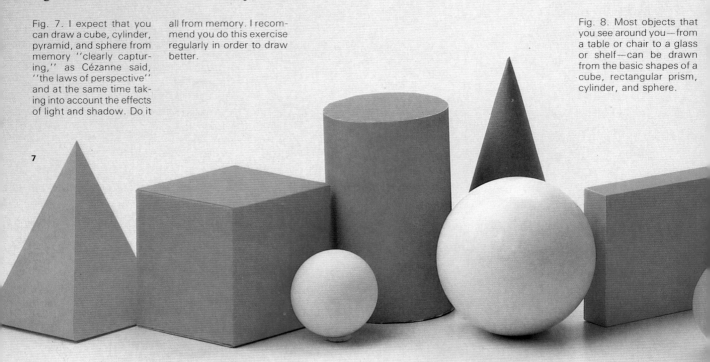

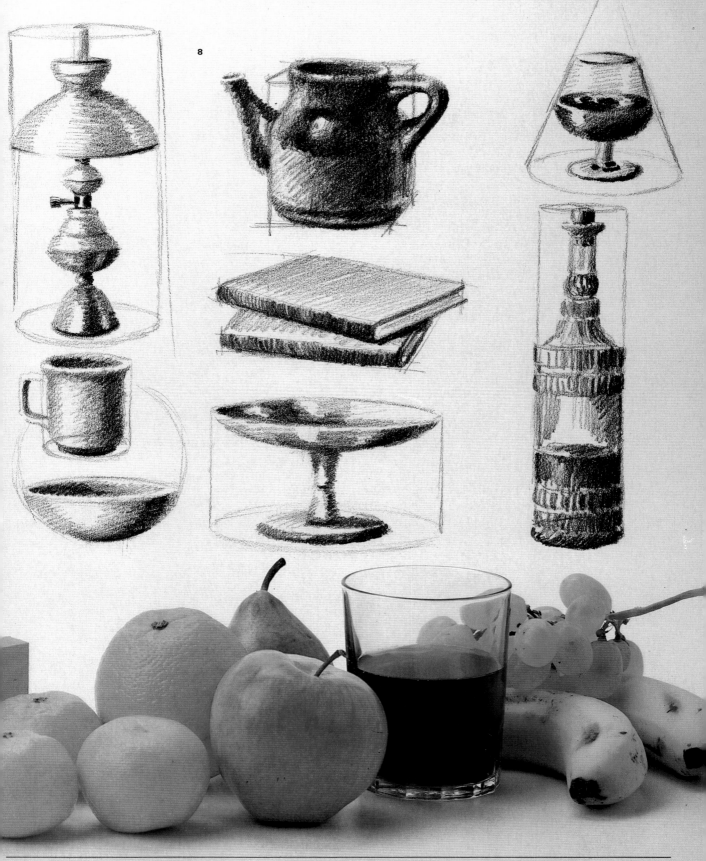

8

Dimensions, Proportions, and Sketches

A good drawing, which in turn leads to a good painting, is born from a good rough sketch. Sketching helps you to calculate the painting's dimensions and proportions. You can use Cézanne's formula of the sphere, cylinder, and cube, or you can use a geometric plane, a square, rectangle, oval, or circle. To sketch this ceramic pot and flowers, I have **observed** the setup and calculated the flowers' dimensions—their height in relation to their width. I did the same with the pot, studying the dimensional relationship between the flowers and the pot, and establishing the dimensions of both bodies. All of this mental calculation allowed me to draw this initial sketch (fig. 10A). Then I studied and compared the setup's internal dimensions as a whole (fig. 10B). I finished the exercise with the classic system of imagining horizonal and vertical lines that determine the situation of points and forms. In summary, the resulting box can reduce the setup's main mass leaving out the accessories, just as we can see in the adjoining box (figs. 11A, B, and C).

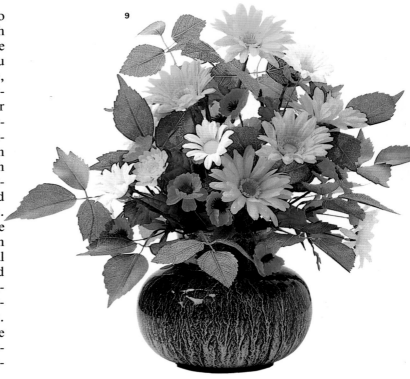

9

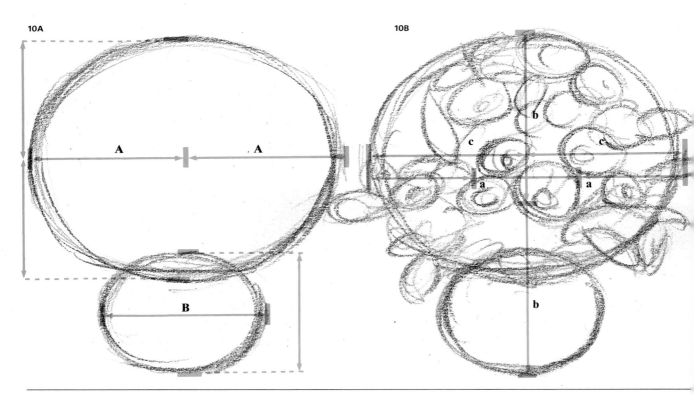

10A

10B

Figs. 9 and 10. All subjects and bodies can be sketched in basic forms, such as circles, ovals, squares, rectangles, and triangles. In the case of this setup, made up of a ceramic pot with flowers, it can be reduced to two ovals or ellipses like the ones I have drawn in figure 10A. How do we determine the dimensions and proportions of this and other setups? By comparing distances. Here, you can see the oval corresponding to the flowers measures exactly twice the width of and height of the oval corresponding to the ceramic pot (A and B). Then the drawing or painting itself of the setup starts, taking into account situa-

tion, dimensions, and proportions of some leaves and flowers in relation to others. Apart from finding repeated distances in the setup the artist is capable of imagining horizontal, vertical, or slanted lines that determine the forms' situation: angle A, for example, indicates the place and the proportion of the series of daisies, while the vertical b determines the situation of contours, centers, and so on, of the flowers and leaves, the horizontal c allows the white daisy on the right to be placed, as well as the leaves of the center and left, and so on.
A correct outline sketch and drawing allow us to paint correctly (10C).

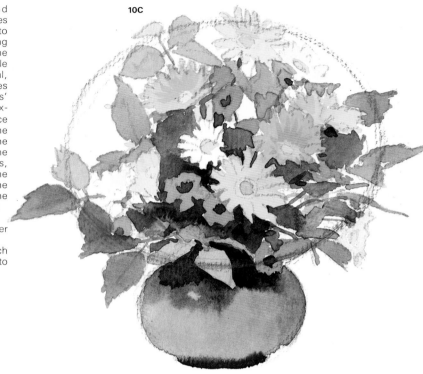

10C

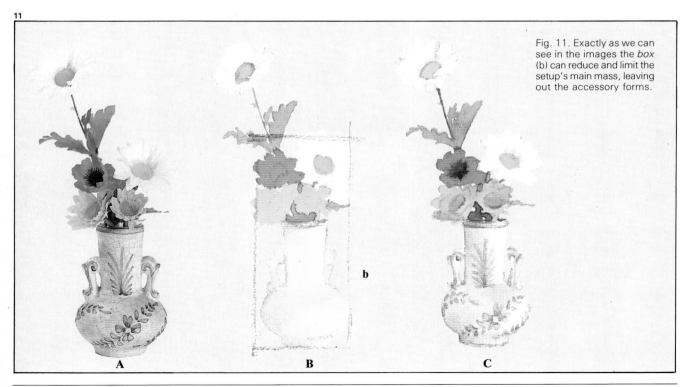

11

Fig. 11. Exactly as we can see in the images the *box* (b) can reduce and limit the setup's main mass, leaving out the accessory forms.

b

A B C

The Valuists with Light and Shadow

For centuries, the artist has always been preoccupied with the volume and the effects of light and shadow on the setup; in other words, representing the third dimension. Leonardo da Vinci (1452–1519) said, "Draw slowly and observe which lights are the brightest and which shadows are darkest; also find out how and when they mix." Jean-Baptiste-Camille Corot (1796–1876) advised: "the first two things in art that should be studied are form and value." Edouard Manet (1832–1883) said, "I search for full light and full shadow; everything else is already there." The artists up until the twentieth century painted the effects of light and shadow taking into account the highlights, the brightest planes, the object's own shadows, the reflected light, and the projected shadows.

At the beginning of this century, in 1905 to be precise, **les fauves** (the wild beasts) appeared. This aesthetic movement, led by Henri Matisse (1869–1954), was concerned with the use of pure, bright, explosive color —not tone.

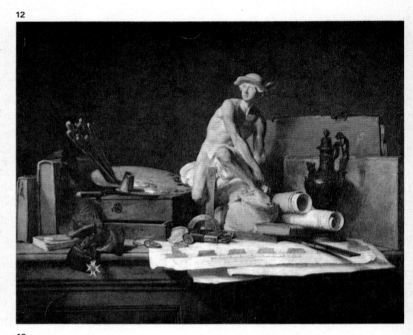

12

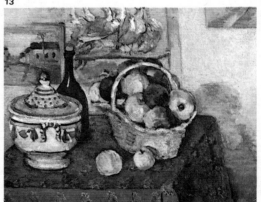

13

Fig. 12. Jean-Baptiste-Siméon Chardin (1699–1779). *Tributes to Art and Its Rewards*. Hermitage Museum, Leningrad. This is the eighteenth-century French painter's most famous still life. It is a classic example of a valuist's use of light and shadows.

Fig. 13. Paul Cézanne. *Still Life with Soup Pot*. Orsay Museum, Paris. Although a modern forerunner painter of cubism and

other later trends, Cézanne painted with light and shadows.

Fig. 14. Isidre Nonell (1872–1911). *Still Life*. Museum of Modern Art, Barcelona. Nonell was a great Catalan painter whose art was characterized by its simplicity, though he always gave special attention to the setup, as you can see in the still life shown here.

Fig. 15. Salvador Dalí (1904–1989). *Bread Basket*. Dalí Museum, Figueres. Salvador Dalí, master of surrealism, gave special attention to finishing his themes with great detail and meticulousness similar to hyperrealism, employing a resolution that is absolutely valuist.

Fig. 16. I painted this still life in oil, which is made up of a ceramic pot and some fruit, within the valuist concept, highlighting the setup's volume and form with lateral diffuse light.

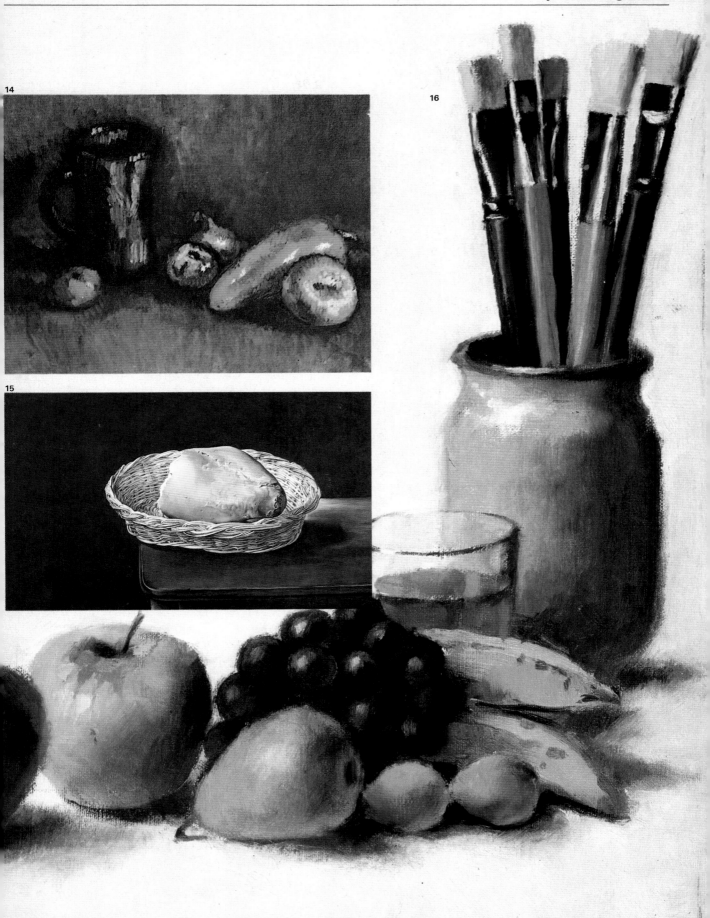

The Colorists

Even though the impressionist painter Manet had said he looked for "full light and shadow" in his paintings, it was his painting *Le Fifre (The Fifer)*, painted in 1886, that first shaped the idea of the *colorist* painting, consisting of colored planes without light or shadows. *Le Fifre* has an ochre-gray background without floor or walls; there are no lights or shadows. It is flat, despite the fact that there really is a background. There is black, a flat color, and red in the trousers, in which we can barely see a few lines for creases. The face has hardly any light or shadows either.

At the end of the century, van Gogh and Gauguin were already painting flat colors, disregarding the play of light and shadows.

In the Autumn Salon celebrated in Paris in 1905, an exposition of paintings with raw, violent colors, and distorted forms that looked as if they had been painted by beasts took place. The artists were called *les fauves* by the critics, a name that remained as a definition of this style of painting. *Les fauves* were Matisse, André Derain (1880–1954), Maurice de Vlaminck (1876–1958), Georges Rouault (1871–1958), Pierre-Albert Marquet (1875–1947), and others. They are the colorist painters who had a lasting style, valid and attractive because it is less figurative and academic, more creative. The artists came to the conclusion that color can express everything without having to resort to volume or the setup.

Fig. 17. Edouard Manet. *The Fifer*. Orsay Museum, Paris. From a series of Japanese prints that arrived in Paris around the middle of the last century, the impressionists studied the possibility of painting with flat colors while totally ignoring the classic play of light and shadows.

Fig. 18. Vincent van Gogh. *Laurel Rosebay or Rose*. Private collection, London. Van Gogh, already within the expressionist framework, painted many pictures from the idea of representing the form exclusively with colors.

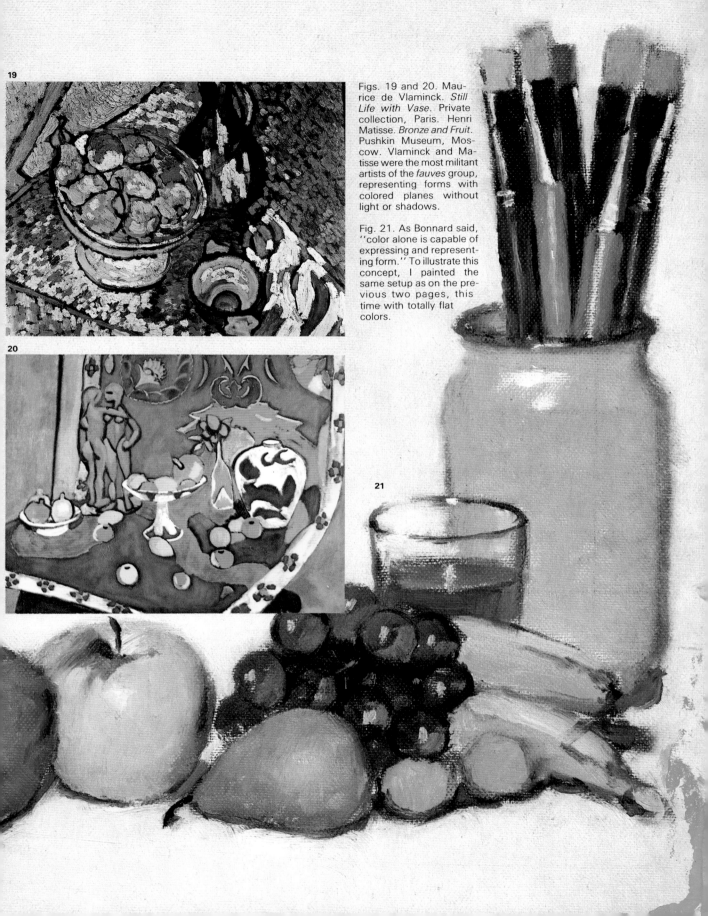

19

20

Figs. 19 and 20. Maurice de Vlaminck. *Still Life with Vase*. Private collection, Paris. Henri Matisse. *Bronze and Fruit*. Pushkin Museum, Moscow. Vlaminck and Matisse were the most militant artists of the *fauves* group, representing forms with colored planes without light or shadows.

Fig. 21. As Bonnard said, ''color alone is capable of expressing and representing form.'' To illustrate this concept, I painted the same setup as on the previous two pages, this time with totally flat colors.

21

Painting, Composing...

We are in José M. Parramón's studio. There are many paintings, books, easels, palettes... and a typewriter. Parramón is an editor, painter, and author of more than thirty books translated into more than ten languages.

"What are you working on now?"

"On a book about color—it's a fascinating subject about which there are many things to be said."

We discuss Rubenistes, Poussinistes, colorists, and valuists... and finally we start to work. Parramón is going to paint a still life composed of fruit, plates, glasses, jars, and kitchen utensils.

"The still life composition doesn't start at the moment of painting, but when you distribute the elements in the space you are going to paint," Parramón says.

But even though Parramón has decided to concentrate on the problems of composition, he also wants to include an additional difficulty: the textures of the materials and the different pictorial treatment that each of the materials' surfaces require. For this reason he uses very diverse materials: glass, copper, several kinds of fruit...but this is for later. In the meantime, the problem is in the distribution.

The Distribution of the Elements

"There are many ways of distributing objects in a space," the painter comments while he prepares to begin. At the moment the objects are not distributed, they are simply where they were put, jumbled together on a table covered with a white linen tablecloth.

The distribution sometimes appears to be spontaneous, but very often it is the product of a lot of calculating and testing.

As a rule, the elements are distributed in a space at different angles and planes, but they can also be placed in a line, one next to the other, as in the well-known still life by Francisco de Zurbarán (1598–1664) in 1663. It was the only painting that this artist signed and dated.

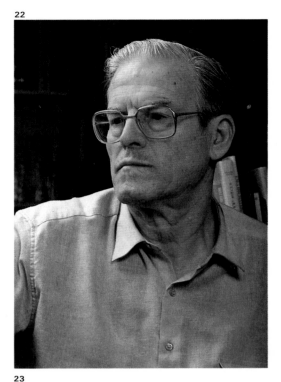

22

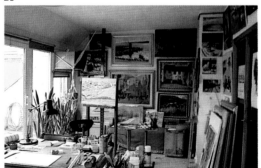

23

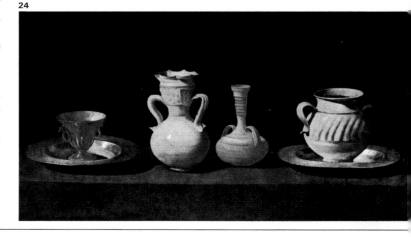

24

Fig. 22. José M. Parramón, drawing teacher and director of the Watson-Guptill Painting Library, is going to paint a still life, and at the same time will comment on how to compose a picture. "A still life," says Parramón, "is the best way with which to study artistic composition given that the painter can select it and study everything: the setup, illumination, situation, distribution, background, and color."

Fig. 23. Parramón's studio measures 17½ feet × 22 feet (4 × 5 m) and is on an upper floor with good windows that allow him to work under excellent daylighting conditions.

Fig. 24. Francisco de Zurbarán. *Still Life.* 1663. Prado Museum, Madrid. When speaking of still life paintings and artistic compositions, it is important to remember this famous picture by the Spanish painter Zurbarán, which situates the setup's elements in a row, one next to the other. Despite this, the painting is very agreeable and it meets Plato's rule, "composing is finding a *unity* within the *variety*."

The Setup

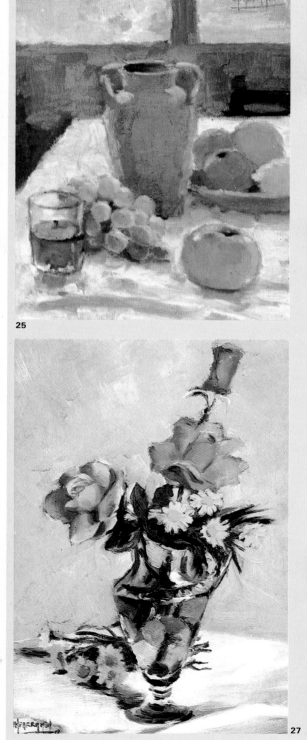

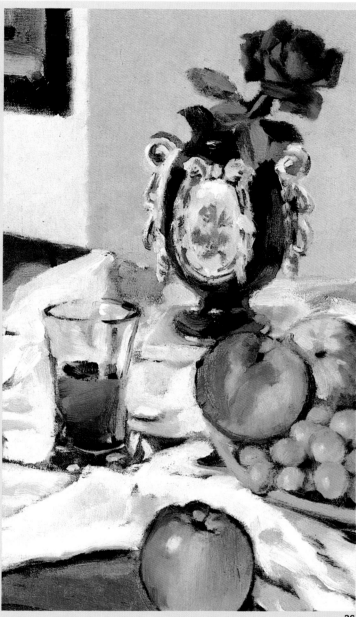

Figs. 25 to 27. Here are some examples of still lifes by Parramón. See the colorist resolution on the lower left-hand side that is determined by flat colors that have practically no shadows of the elements that make up the setup. This same pictorial conception can be appreciat-ed to a certain extent in the vase (left) and in the detail of the picture showing the ceramic vase with a rose in it (above) that Parramón painted using the idea of lighting and coloring in Cézanne's still life paintings.

Light

Lighting is an important factor in the composition of a painting. Now, for example, we can see the objects illuminated by the light of day: a rainy day, light coming from the northeast, from behind the objects: "It's too hard, you could say it's practically backlighting," says Parramón. He does not want shadows that are too accentuated.

He corrects the excessive contrast with a simple desk lamp, directing its beam onto the white surface, which in turn reflects light toward the subject. Everything is softened and the brightness is increased. "Now I can imagine a livelier interpretation, more *colorist*."

The Selection Process

We return to the problems of composition: a matter of choice and elimination. One must progressively reduce the collection of elements, leaving only those that really deserve to dominate the painting.

While the painter goes about this job, imagining what effect the forms and colors will produce in the final painting, he is composing and thinking of the works by Cézanne, van Gogh, Matisse, and others.

An experienced painter, a painter with acquired visual culture spurred on by curiosity, *copies* without realizing it.

Such painters copy their own mental archive of other painters who preceded them, and delve into this conscious or unconscious memory when preparing each new painting.

28

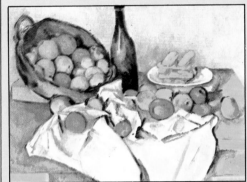

Figs. 29 and 30. Paul Cézanne. *Still Life with Basket of Apples*. Chicago Art Institute. Paul Cézanne. *Curtain Still Life*. Hermitage Museum, Leningrad. The still life theme was one of Cézanne's favorites. The basic elements used by Cézanne in his paintings were generally such things as a tablecloth, a plate or bowl of fruit, a bottle, and something ceramic.

29

30

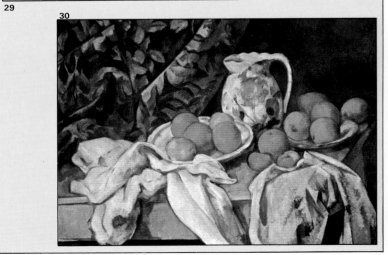

Fig. 28. Before starting to paint, the artist selects the elements for his or her picture, then places them on a table and studies their form and illumination. Parramón, in this case, decides to soften the contrast with a light reflected onto a white canvas.

Plato's Rule

To compose is to put into order, or to "displace the picture's elements so as to achieve a satisfactory whole."

The still life is the most adaptable of styles for the painter. He or she may manipulate the subject before or even while painting. It is for this reason that the still life is the best theme with which to learn composition.

Van Gogh said it was the best genre to learn painting because it is done in the studio where there are no onlookers, and the painter can feel at ease.

But is there any rule for achieving an agreeable whole?

Here is Plato's time-honored rule: *"To compose is to find unity within variety or variety within unity."* (For more informa-tion about his rule, see the box at the foot of this page.)

Remember that the superimposing of objects, that is, the partial covering of one object by another object, almost always achieves good composition results because it contributes to a unity that does not lose variety.

Now the painter looks for a composition whose guide could be a triangle. The creases of tablecloth on which the objects stand must also be taken into account. Even here we can use a few tricks, for example, by inserting a pin to obtain an exact crease.

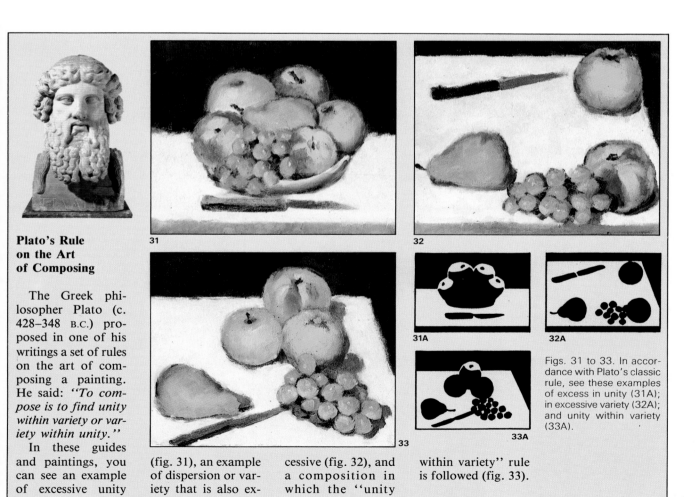

Plato's Rule on the Art of Composing

The Greek philosopher Plato (c. 428–348 B.C.) proposed in one of his writings a set of rules on the art of composing a painting. He said: *"To compose is to find unity within variety or variety within unity."*

In these guides and paintings, you can see an example of excessive unity (fig. 31), an example of dispersion or variety that is also excessive (fig. 32), and a composition in which the "unity within variety" rule is followed (fig. 33).

Figs. 31 to 33. In accordance with Plato's classic rule, see these examples of excess in unity (31A); in excessive variety (32A); and unity within variety (33A).

The Art of Composing

Parramón tells us that the objects should be placed in a position that will clearly show what they are. See, for example, in figure 36, the lemon is at the top of the fruit bowl. It is placed in a way that makes it difficult to identify as a lemon. In figure 37, there is no doubt as to what type of fruit it is.

The painter has finally selected the objects that are going to make up his composition. It is somewhat similar to Zurbarán's composition in frieze, though this one has hues. There are several planes, and above all, there is a lot of space in the lower part of the setting. The table covered with a white tablecloth on which the objects stand will take up a great part of the space in this painting. Parramón does a sketch of the subject using charcoal.

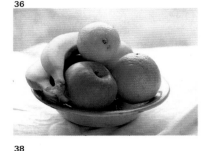

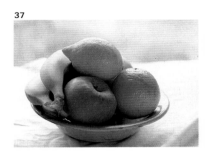

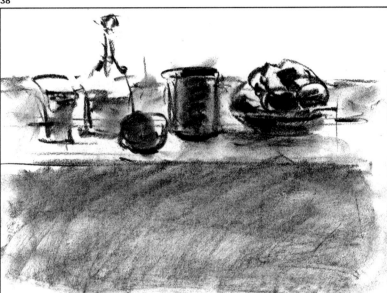

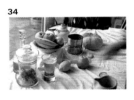

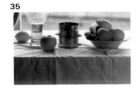

Figs. 34 and 35; 38 and 39. Out of all the elements selected for this still life, Parramón finally chooses four and a bowl of fruit (fig. 35). He then draws some charcoal sketches in an attempt to find a composition based on the *golden mean*. "I'm going to put these five elements in the mid-upper part of the picture, highlighting the importance of the tablecloth as an element of composition," Parramón explains.

Figs. 36 and 37. Having now chosen the elements for this still life, the artist must choose a position and situation that will allow all the elements of the painting to be recognizable. In this example we see that the lemon is more clearly a lemon seen from a profile (fig. 37) than from the front (fig. 36).

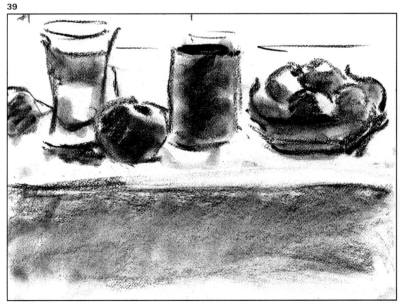

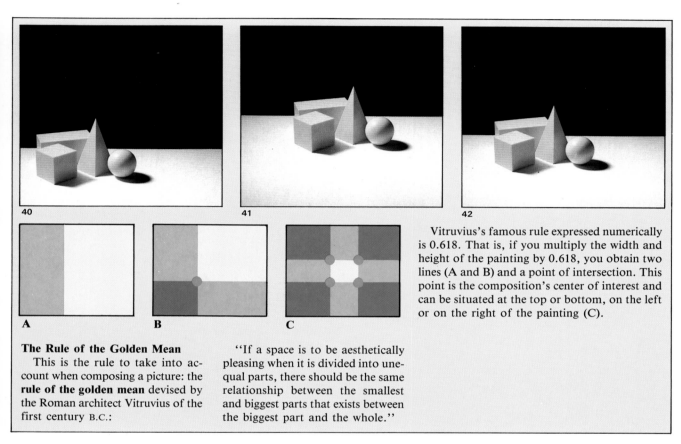

40 41 42

A B C

Vitruvius's famous rule expressed numerically is 0.618. That is, if you multiply the width and height of the painting by 0.618, you obtain two lines (A and B) and a point of intersection. This point is the composition's center of interest and can be situated at the top or bottom, on the left or on the right of the painting (C).

The Rule of the Golden Mean

This is the rule to take into account when composing a picture: the **rule of the golden mean** devised by the Roman architect Vitruvius of the first century B.C.:

"If a space is to be aesthetically pleasing when it is divided into unequal parts, there should be the same relationship between the smallest and biggest parts that exists between the biggest part and the whole."

"Charcoal is great for sketching because you can obtain very intense blacks and stump at the same time, and get lights and shadows, all highlighted at an extraordinary speed," says Parramón.

Parramón uses the famous golden mean when he composes his study. It consists, as you know, of obtaining a harmonious relationship between the two dimensions, multiplying the smallest part by 0.618, which gives you the largest part as a result. It is not exactly 1/3 or 2/3, the relation is 5/8. In one of Parramón's studies, as you can see, he was not far from guessing the golden mean.

Now and then he uses an eraser to modify small details—it is a malleable eraser that is used especially for charcoal since it eliminates a black mass in one stroke.

The third was the best. The artist took advantage of the first composition in his first studies, the most modern and daring; but the relative size of the objects in the picture has been taken from the second study. The bottle has been removed; he has changed it for a glass. The lemon, which was before forgotten at the back, is now up front. This will be his composition: objects in the third upper part of the picture, but covering practically all of this section.

Figs. 40 to 42. Within a given space, a square, for example, what is the ideal situation for composing and highlighting the main image? The placing of a collection of elements on one of the sides leaves too much space around the image, which disperses the viewer's attention (fig. 40). The application of the *rule of the golden mean* positions the elements perfectly, aesthetically speaking (fig. 42).

First Stage: Color Outlines

Parramón starts to paint on a 12 format landscape canvas. He says he would prefer the figure format, which is wider, but doesn't have a canvas that size. It is more suited to the kind of composition he is painting, so he decides to modify the format. He paints black on the right part of the canvas —the part he is not going to use—transforming the landscape format into a special one, somewhat closer to a square format.

His next job is to get rid of the white of the canvas, which he does by "filling in" the lower space with very diluted paint, a neutral gray, brought very close to the warm color range by incorporating ochre.

With that he has covered almost 5/8 of the lower part of the canvas. He did it with a thick bristle brush, number 24. He did not take any measurements, it was all done by rough calculation, basing it on his study while looking at the setup.

Using a somewhat darker gray, Parramón begins a study of the elements that make up this still life, and right away he incorporates colors into it. He wants to obtain volume from the very beginning, he wants forms, not only outlines: paint from the start, do everything at once...

Wetting a rag with turpentine, he erases an area he does not like, then he immediately goes over it again.

There are many colors in play, lots of mixes that the Italians call *provatura*: the colors are applied at the same time as the forms.

The painter has created notorious difficulties for himself. He tries to work with a range of colors that are more muted than in reality. There are problems such as the proximity of the beer's yellow color and the yellow of the lemon, two very similar tones that should be radically different from one another. (The lemon has more lemon yellow, and in the beer there is more cadmium.)

But neither color remains that way for long; Parramón immediately covers them with another. This is the *provatura* phase.

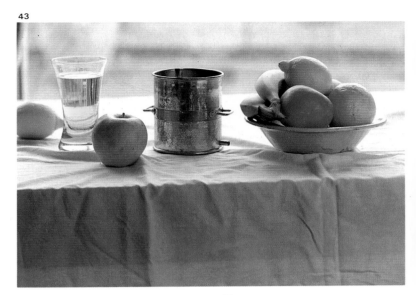

43

44

45

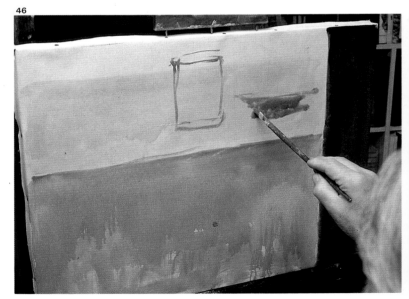

46

The essential elements are now in place: the objects, the horizontal part of the tablecloth in the upper part, the vertical in the lower part. "This is already a painting," says Parramón, quoting Jean-Auguste-Dominique Ingres (1780–1867). "The real painting is what it is in any of its phases: in the sketch stage, half completed, and at the end. Although it's difficult to decide when it is the end of a painting." As an authority to corroborate this last comment, Parramón quotes Pablo Picasso (1881–1973): "A finished painting is a dead painting."

47

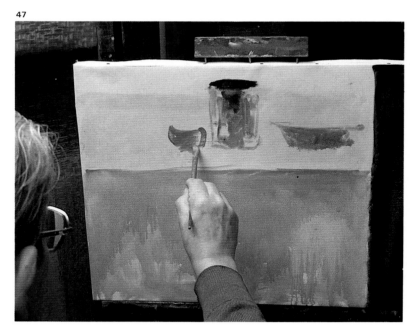

48

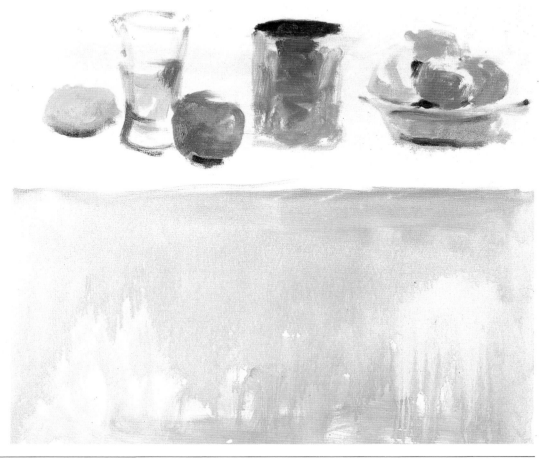

Fig. 43. This is the setup, composed of, from left to right, a lemon, a glass of beer, an apple, a copper pot, and a bowl of fruit. The backlighting illumination with the reflected screen softens the intensity of the shadows.

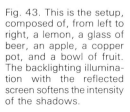

Fig. 44. Before commencing the picture, Parramón modifies the canvas's shape —a 12 landscape— by painting a division from top to bottom, which leaves an almost square-shaped canvas.

Figs. 45 and 46. He starts the picture by using gray paint (white, black, and ochre) that is very diluted in turpentine for the table-cloth. With the same color, he begins to draw the picture's forms (fig. 46).

Figs. 47 and 48. Parramón continues with the first color outlines, thus definitively placing the elements in his still life.

Second Stage: "Advancing" the Painting

Going against his custom, Parramón decides to include black, or more specifically, ivory black. He does this in order to obtain a neutral gray and ochre without having to make up complicated mixes: so with ochre, black, and white he gets gray. The gray allows him to mark the shadows that are *projected* by the objects on the tablecloth.

The painter hesitates. He must decide whether the whole of the upper part will have a background or whether it will become lighted tablecloth, or will simply be white. He paints a yellow strip in the top part, which will form the background. Now we have three main color divisions: the yellow top part, the grayish white in the center, and the darker gray of the lower part.

But Parramón also "advances" with the objects: the fruit, glass, plate, and copper pot. It all starts to have relief, by obtaining shadow and volume. In the apple's shadow he applies green, a complementary color of red. Mixed with the carmine that constitutes the apple's main color, the illuminated part, the green gives the apple a muted color that satisfies Parramón.

Now and again he uses his fingers: "It's not good for a painter to spend too much time on one particular element while neglecting the rest. I've just done that with the apple and now I regret it."

The yellow of the top part has a brief life. Parramón wets a rag with turpentine and erases it.

49

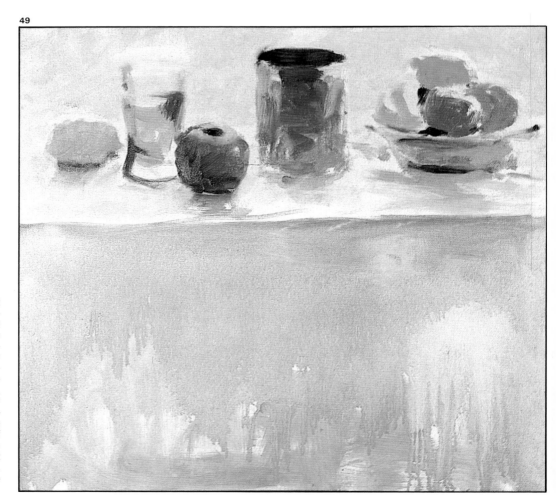

Fig. 49. Applying great strokes of color, "he advances everything at the same time," just as Ingres recommended. The composition and color are now established with a first impression finish. "According to how you look at it, this painting could already be finished," says Parramón, adding, "maybe when we see the test proof [what you, the reader, can see now] I may regret not having left it as it is now, capturing this first impression."

Paint, Rectify, Paint

"... Rectifying is for Experienced Painters"

"Rectifying to correct an error," says Parramón while he repaints the apple in red, "or even rectifying to obtain a better result is always valid. And it's easy when painting with oils because you can paint over [fig. 50B]; or you can scrape or erase with a rag [50A]. But you might not be happy with the immediate result [fig. 50C]; and painting again readjusting shadows with complementary colors—green with carmine—by rubbing or scraping [figs. 51A and B]... until you achieve a satisfactory result [fig. 51C]."

Some corrections can be drastic: in figure 44 (page 20) we saw how Parramón decided to rectify the canvas's format by painting black along the right-hand side to create an almost square format. So when the painting had reached the fourth stage, Parramón thought about the possibility of reducing the width of the painting even more by applying another division on the left-hand part (fig. 52A). "As if we were seeing a still life through an open door," says Parramón. But straight away, regretting this idea, he erased the division with a rag soaked in turpentine and the picture was as before (fig. 52B).

"Don't be afraid of making such mistakes, or of checking and rectifying, especially when painting with oils, an opaque medium that doesn't dry so quickly as other mediums. It allows us to paint, rectify, paint...."

50A

50C

50B

51C
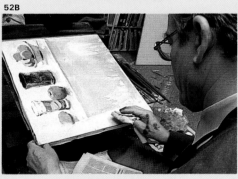

51A

51B

52A
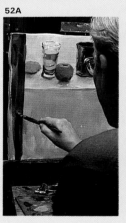

52B
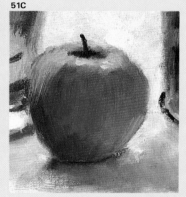

Third Stage: Producing Texture

53

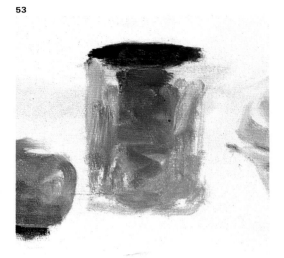

Parramón goes back to work on the apple, giving it relief, all the time thinking that if he resolves this element's volume the rest will come together naturally. He is not convinced of the apple's color. He takes his rag and removes most of the color, which leaves him feeling more satisfied with the relationship between this color and the others in the picture. As you can see, he also paints by erasing.

"Painting is a constant discovery," says the artist. "To paint is to create, that's why it's such fun. Maybe the only thing better than painting is playing a musical instrument."

The apple is almost back to its original state. He leaves it for now and turns to the cylindrical copper pot and explains the difficulties it entails: "It seems really easy. It's only copper color, but in reality many colors will have to be used, all of them very mixed and very muted, to obtain a good resolution."

Parramón alternates between thick and thin brushes as he works on the pot.

54

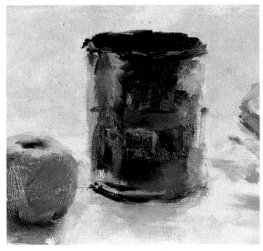

55

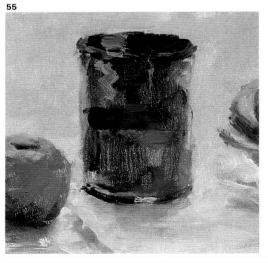

56

Figs. 53 to 56. You can see the step-by-step process in these four reproductions of the copper pot with an acceptable resolution at the beginning (fig. 53.); several forms and colors of the reflections that were dictated without studying the setup's background (figs. 54 and 55); and the final result after stopping, looking, and observing the forms and colors attentively, studying the setup in reality (fig. 56). "I must confess that after the first outline I think I got it right, letting myself improvise by looking at without really analyzing the setup's forms and colors."

Copper, Glass, Fabric, and Fruit

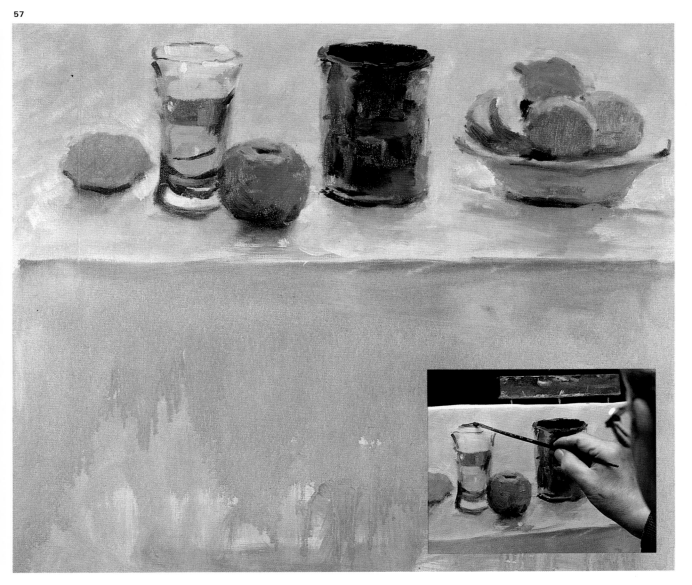

57

Now Parramón is starting on the fruit bowl with the fruit inside. But he immediately returns to the apple.

The apple is constantly changing color, and its strength and intensity also change continuously. He seems absolutely obsessed with this apple.

Now he has begun the glass of beer. While the glass acquires relief, so does the copper pot, and its role in the whole becomes more defined. "The glass is very pleasing," comments the painter while he goes back to his old obsession, the apple, which still does not satisfy him.

On the other hand, the 5/8 lower parts, the vertical of the tablecloth, continue in their original state. Since then the painter has not touched this part.

Fig. 57. The painting advances. The tablecloth has not yet been solved. The pot does not correspond to the material it is made of —copper. The glass and the apple, as well as the rest of the picture, are in an intermediary stage in which what counts are the strokes and details that determine and fix the elements' form.

Fourth and Fifth Stages: The Tablecloth and the Finish

58

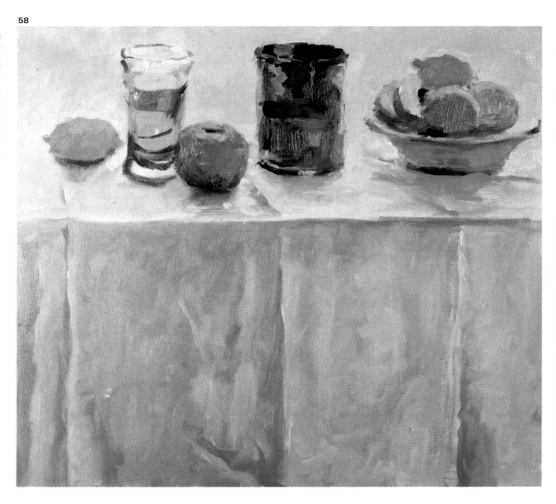

Fig. 58. Reaching this penultimate stage, Parramón says, ''It's not a good idea to stay in one part of the painting and become obsessed with it. The best thing is to stop or forget it and go on to another part of the picture. Later on you can return to it with more serenity and that will allow you to decide things more clearly.'' This is what Parramón has done in practice in this stage. He left the top part of the picture and drew and painted some forms, shapes, and creases in the tablecloth.

At last he starts to work on the lower part of the painting and on the vertical part of the tablecloth that covers the table on which the objects are found. Parramón works fast and confidently: ''This is an easy part,'' he says happily.

Nevertheless the ease with which the author paints, along with the finished effect of the tablecloth, is notable; as it acquires relief, it contributes to the relief of the painting in general.

A few creases and a play of grays are enough to give the picture dimension.

This play of grays is very simple: a medium gray, a darker one, and an almost gray-white. The creases are elaborated with these three values.

But it is important that there is not only gray in the background: it is a question of shading. Every segment must have—apart from a determined *value*—its own color. It must have a rich gray full of shades, not a uniform extension without any other color apart from the three colors (light, medium, and dark).

''I'll leave it; tomorrow or the day after tomorrow I'll take a look at it to see whether anything can be changed.''

Two days later, Parramón sits in front of the painting, with the setup still in place. He contemplates the painting and looks at the setup. Finally he says: ''The empty, white background has no meaning,'' and straight away begins to paint an ivory-cream division. Then he signs it.

59

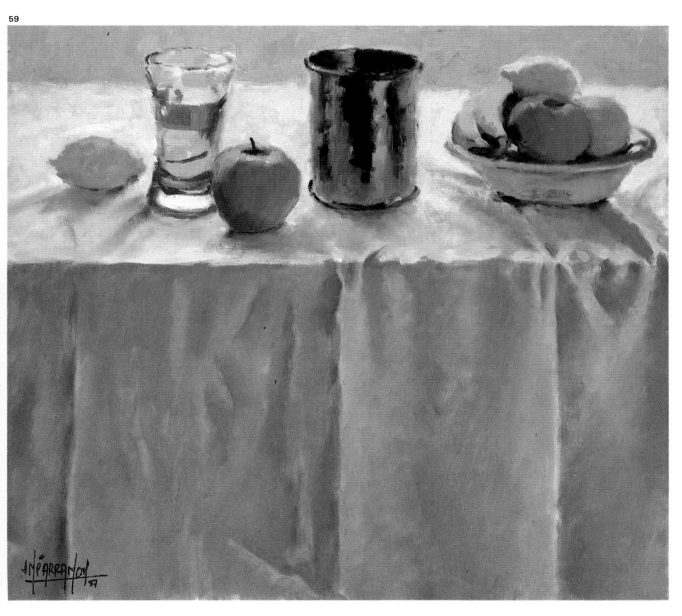

Fig. 59. As you must already know, many artists paint two or three pictures at the same time, alternating one with the other according to how the painter feels, the illumination, a lighter or darker day, and so on. This is a good way of working since such time lapses permit the final result to mature. Titian would put his half-finished paintings with their faces against the wall for hours or days so as to be able to return to them with better clarity of judgment. Parramón comments: ''Between the previous state and this one, there was a twenty-four-hour lapse of time. It was enough to increase my capacity to judge and decide on how to adjust the forms and colors of the apple, copper pot, and glass, as well as to see I needed a background, a division that would determine the end of the tablecloth and table.''

Pictures, Engravings, and Tapestries

60

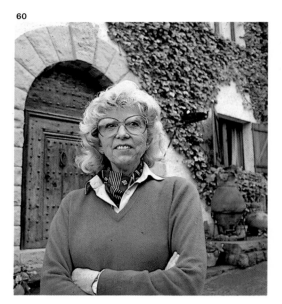

61

62

Fig. 60. Born in France, Mercè Diogène spent her childhood in Barcelona, although she did her last years of school in Marseilles. A renowned painter, she has also made tapestries and engravings, creating a certain artistic aura that allows her to live art in its totality.

Figs. 61 and 62. The artist's studio is in the top part of her house, an old, renovated mansion. The studio receives a lot of light through several large windows. When she starts to paint, Diogène positions herself to the left of the canvas, which, according to the classic rule, allows the light to enter through the window.

Mercè Diogène's studio, situated in her house, is on the side of a hill, in a residential area not far from Barcelona. Her studio is in the highest part of her house, an agreeable, renovated old mansion, open to the four winds and surrounded by greenery. Also on the property, very near the house, there is another somewhat smaller building, where the painter has her looms. In addition to painting and engraving, Mercè Diogène also makes tapestries.

Diogène was born in Perpignan, France, in 1922, but has lived in Barcelona since her childhood, although she did go to school in Marseilles.

The painter forms a part of the Mérite Artistique Européen and in 1982 won the Salon du Val d'Or honors prize. Mercè Diogène's works have been exhibited in several European and South American countries, as well as in Japan.

In 1985 she made an enormous tapestry weighing one ton for a Barcelona radio station.

The paintings Diogène is currently preparing for exhibition, which fill her studio, are seascapes ranging in size from number 4 to 120. Although the painting she is going to do for us is a still life, she will do it on a 25 format landscape canvas.

Elements and Disposition

Mercè Diogène does a lot of studies in black and white and color. Very often these studies serve as a starting point, but on other occasions she paints from memory, or with the setup in front of her, as is the case now.

You already know that painting in front of the setup requires the painter to make preparations before taking up his or her brush. That is, in the case of the still life, selecting and positioning the theme's objects: "It's not only a problem of composition, but also a selection of color ranges and color harmony," says Diogène.

Diogène's Colorist Work

63

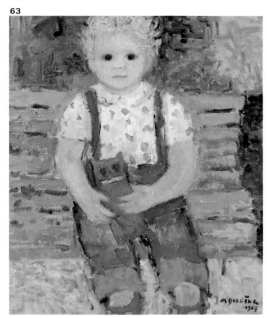

64

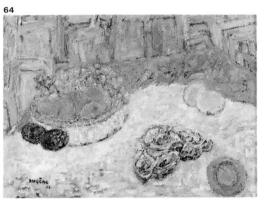

65

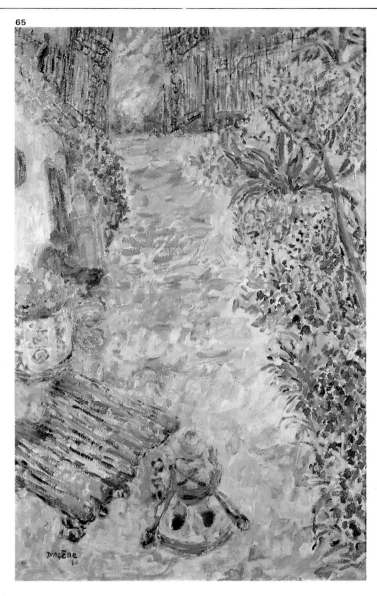

Figs. 63 to 65. As a general rule, it is possible to say that there is a relationship between the way a picture is painted and its final result. Diogène's style, which is similar to the *divisionist* theory practiced by some of the impressionists such as van Gogh and Edgar Degas (1834–1917), and developed by the neo-impressionists Seurat and Signac, among others, creates a real color explosion. A type of *colorism* is created in which the forms lack shadows and are suggested exclusively by the use of juxtaposed lively colors that, according to the theories of optical mixes developed by Seurat, form another color when seen from a distance. The paintings by Mercè Diogène that are reproduced on this page prove that form can appear through color in all its plenitude.

Harmonizing Colors after Selecting the Theme

66

Diogène has decided to paint a still life that she describes as romantic. If she had to give it a name, she would call it *L'èventail*, in honor of the fan she has placed in the left-hand part of the foreground.

There is also a shallow fruit bowl and a simple, cylindrical glass vase that adds to a painting that otherwise has no curves or bends.

The circular porcelain box has that characteristic blue color, *bleu Sèvres*, which is near to ultramarine blue. The mauve-colored flowers are winter hydrangeas. The white ones are narcissus that bloom in February and are the last winter flower, and the yellow forsythia is the first flower of spring.

The modernist fruit bowl balances the little bowl on the right that is lower than the one on the left. There are two oranges and

a lemon in the bowl on the right and some mandarins in the other bowl. The mandarins are very small, "they're almost like Chinese oranges," the painter comments. There are two apples between the fruit bowl and the porcelain box.

All of the composition's elements have been placed on a typical Arabic table. "It's a Moroccan table," she explains, "and was given to me by one of my first teachers, who was a great painter and restorer. One learns a lot restoring paintings."

At this point, as you have seen, before having applied a single brushstroke, the painter has three factors in her favor that can help her to paint a good picture: intrinsically beautiful elements, exquisite taste in her positioning of those elements, and a wise and gay harmonization based on complementary colors (blue/orange and yellow/violet) with a predominant warm tendency.

Diogène's Palette

"I'm extremely orthodox when it comes to color distribution. I normally go by what I was taught. This classic distribution of the palette has a lot of advantages, because in this way you find the color in the place you need it without having to look for it. It's a little like a typist who doesn't have to look at the keys when typing."

Fig. 66. This is the setup chosen by Diogène for her still life. She has not only taken care in the position of the elements, but also in her selection of texture and color tendency (warm, cool, or neutral).

67

Fig. 67. The colors of her palette are placed in a deliberate way enabling her to find the desired color at any given moment without having to look away from the canvas. From left to right they start with the cool colors, then the warm, finishing off with white.

Palette and First Stage

Diogène's palette is distributed left to right as follows:

> viridian
> emerald green
> sap green
> ivory black
> ultramarine blue light
> ultramarine blue dark
> cobalt blue
> carmine madder
> vermilion
> cadmium red
> ochre or Indian yellow
> cadmium yellow light
> cadmium yellow deep
> lemon yellow
> white

The painter specifies some details of her palette: she likes to have five or six greens; the ochre and Indian yellow contain ample yellow pigment, almost as much as yellow itself, and they are much less aggressive; she does not tend to use siennas or burnt umber.

Diogène starts by sketching the enormous lines of the picture with a yellowish mix. Next she stains with another color, light violet; afterward with blue and then green. That is, she marks each one of the elements of the still life with its corresponding color. In one way it is like a color drawing in which each one of the elements has its own color, but only in outline; just like children's drawings or certain studies made by Picasso.

"Before I start painting," says Diogène, "I elaborate the picture mentally. Sometimes I even make a quick sketch."

68

Although, she adds, that when it is time to begin painting, she does not normally put such a sketch in front of her to copy it, but only to remember things that she has forgotten.

Fig. 68. Mercè Diogène, who like other colorists sees the still life as a succession of color stains that must be given volume and whose objects must be defined by *drawing with brushes*, makes sketches with the basic colors that she *sees* in the final still life that she later fills with color.

Second Stage: Scraping Brushstrokes

The artist hardly uses turpentine, but she does not paint with thick impasto either. She alternates her bristle brushes (filbert and flat) as if they were pencils. She works thickly but with small quantities of paint; in this way the paint does not run all over the canvas. She does not *slide* the brush, she *scrapes* it.

Diogène's brushstrokes do not fill the forms right now, they only outline them. But the color harmony is already being applied, because apart from alternating her brushes—from thick to less thick—according to her needs, the painter constantly alternates the color as well.

As you can see, her palette is on a small table in front of the easel. The painter says she does not hold it because if she does she will stain her clothing. Everything gets stained, "even my hair," she adds with a smile.

In this phase we can clearly see the impressionist influences from Diogène's teachers. There is also an apparent joy in the picture, somewhat akin to works of Matisse and Raoul Dufy (1877–1953).

Diogène has now started to use blue in the porcelain box, but also in outline, just like the rest of the painting's elements.

There is sometimes a curious connection between the way a painting is executed and the final result. Diogène's picture is gay, and while she paints she seems to do it with pleasure; without hesitation. She really appears to be enjoying it. Little by little some thick parts begin to appear. For example, the apples start to receive their color. The painter adds as much color to her palette as she needs. She is particularly generous with white, which she uses in abundance.

69
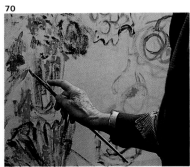

70
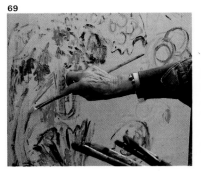

71
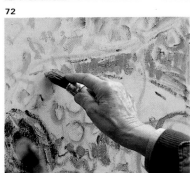

72
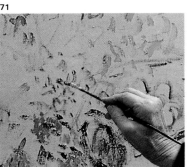

73

Figs. 69 to 72. In this phase of the still life, Mercè Diogène delineates the forms using several brushes that she constantly interchanges. She holds them in a different way depending on the required brushstrokes: sometimes as if they were pencils, thus allowing her to sketch the great strokes of the still life, and with the brush's handle in her hand for the strokes applied from a certain distance. Curiously enough, Diogène also uses a special short brush, almost without a handle, with which she stains and paints tones and brushstrokes.

Fig. 73. Instead of holding the palette in the other hand, as is the custom, Diogène puts it on a stool next to the easel.

74

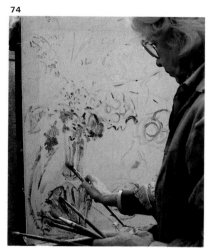

75

76

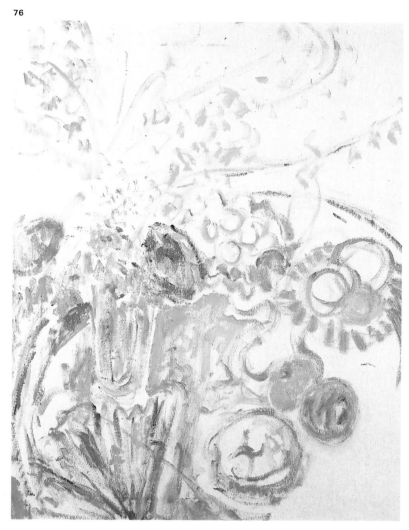

At the end of this stage we can see that the lower part of the painting, except the right-hand triangle, is filled with diverse colors. The upper central area, however, is exactly as it was at the beginning.

"You always have to be doing studies, drawing and painting. I have loads of small notebooks full of studies, in Chinese ink or in wax crayons, that allow me to do studies in color wherever I am. They are things you can keep handy in your pocket. I also use a pen. Some don't go any further than that, they remain just mere studies; others can become in a certain moment the subject for a painting. I have studies in watercolor, too. They're really wax pastel studies that have had water added to them."

Figs. 74 to 76. The painter continues to paint with loose, apparently nonchalant strokes that not only define the forms, but also give volume to the objects in the lower and middle part of the canvas.

Third Stage: Color Explosion

She continues happily with her work. Everything starts to take on color, but the white seeps through everywhere. One of the brushes she uses is short, practically cylindrical.

The painter's palette is covered with different colors. She does not reserve places on her palette for determined color mixes; she makes them here, there, and everywhere, according to her need at that moment. The whole is now a great explosion of colors: "You have to work on everything at the same time, it's important to see the painting as a whole and not concentrate on one small area, because this can make you lose your vision of the whole."

Diogène always prepares her own canvases with the help of a friend. They all have a special primer that she herself has prepared so she can obtain the kind of quality she needs. She always uses linen fabric and never paints on a commercially prepared and mounted canvas.

She now begins to apply a few thicker brushstrokes. Up until now she has *rubbed* the canvas's surface, but now Diogène commences to load the brushes with more material, but not too much.

Fig. 79. Diogène has applied color all over the canvas. At this stage she wants to work everything at the same time, and at the end she will consider the tonal value in every area.

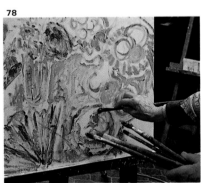

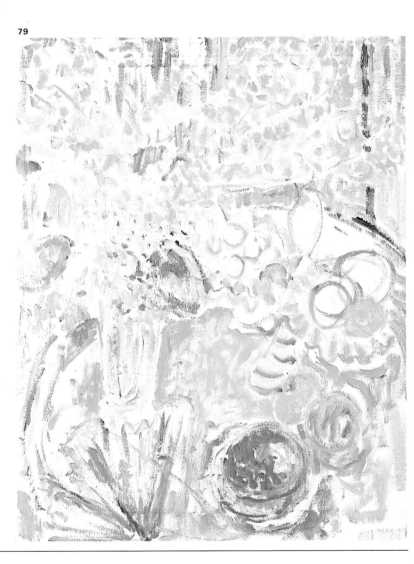

Figs. 77 and 78. Mercè Diogène is aware that color theory is only a starting point in the passionate world of colors and mixes. For that reason, she constantly practices and experiments in the sketchbooks that she always has with her. In the photograph above, we can see her applying color to the still life, seeing and painting it *all* at the same time.

Fourth Stage: Color Makes Forms

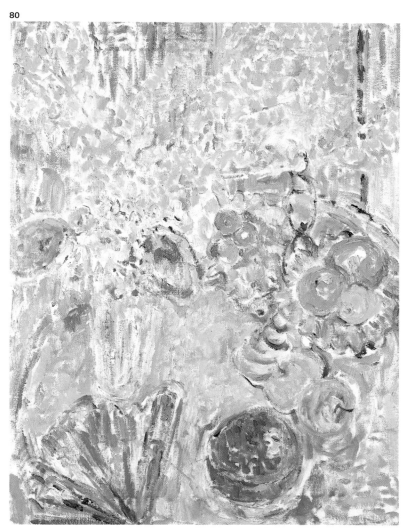

80

"I always use bristle paint brushes. I don't like those made of sable hair because they're too soft. I like hard brushes that pass over the canvas as if they were color sticks. I prefer to rub the canvas, just like a *frottage*." (*Frottage* comes from the French word "frotter." It is a scumbling technique of lightly loading the brush with paint and then rubbing the brush over an area that is already painted and dry.)

While she fills the mandarins with a different paint from that of the oranges—what we could call mandarin orange—the painter comments that she never illuminates her motifs in any particularly special way: she takes advantage of the light there is at the time of painting.

She always applies the paint exactly as it is when it comes out of the tube. The artist only uses turpentine to clean the brushes, which, by the way, she continues to alternate: thin and then thick ones. Sometimes using a very fine brush, she applies small details here and there without concentrating on any one area.

It is oil, but an oil that is so light, it could be watercolor, wax, or colored pencil. The colors are pure and lively, and there are no shadows.

When we say pure, we do not mean they are the result of a mix, but that the painter shies away from muted tones. Do you remember that Diogène's palette contains no sienna or burnt umber? See the harmony of complementary colors in the motif that the artist has accentuated with the violet light. Also the contrast of complementary colors between the blue of the porcelain box and the oranges of the mandarins and the oranges have been accentuated.

"Even though the background is imaginary," the painter says, "the real background [one of her own paintings that stands behind the setup she is painting] also helps me, because it is a color reference for the painting's background."

81

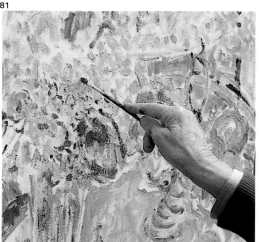

Figs. 80 and 81. Diogène has loaded more paint onto the brush, with which she is not *scraping* the canvas, but filling it with volume. She has applied forms as much with the color coats as through the contrast between colors.

Fifth Stage: The Risk of Dirtying a Wet Painting

"The white helps to give the painting vibration," Diogène affirms. And it is not always the white of the canvas, as if it were a watercolor. Sometimes she applies white to a space that was already white. In this way there is the sensation that it is the color—even white—that constructs the forms.

So far the painter has been working standing up but now she is sitting down. We talk about the artist Edvard Munch (1863–1944) because she has a catalog of a comprehensive exhibit of his work on her table.

"I couldn't introduce the everyday drama of the world into my painting. It'd suffer too much. My painting is an escape from the cruelty of today's hard world."

Diogène is working with abundant white and some blue in the central area of the silver support on which the fruit bowls stand. Although she manipulates reality quite freely—she does not attempt to imitate it—the artist looks constantly at the setup while she paints. She works fast, without rushing, applying touches to the canvas while glancing quickly at the setup, which, although it will not be realistically reproduced, offers inspiration.

All of Diogène's painting is light in appearance. But that does not mean the picture should not take shadow into account. "I have to introduce a certain amount of shadow under the white flowers. But I'll do that when it's dry," she says.

"At this stage you must add things with extreme care so that the painting doesn't get dirty. The risk is very great if the painting is wet. Of course, there's no problem if the painting is dry."

The rhythm is slowing down now. Her brushstrokes are somewhat thicker, producing what we could call volume.

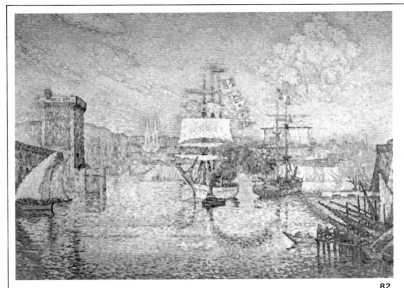

Fig. 82. Paul Signac. *Entrance to the Port of Marseilles*. National Museum of Modern Art, Paris.

82

Diogène's Divisionism

During the last decades of the nineteenth century, Seurat, influenced by Michel Eugène Chevreul and his color theories, developed the theory of *divisionism*. This was a basic technique or style from the neoimpressionist movement. Divisionism, also known as *pointillism*, was the practice of creating colors by using a series of dots or points of colors that, when seen from a distance, formed a mixed, optical effect producing another color; for example, blue and yellow dots when seen side by side produced the color green. Diogène's style is similar to that of Seurat and his followers, Paul Signac (1863–1935), Maximilian Luce (1858–1941), and other more famous painters, who also reflected Seurat's theories in their works: van Gogh, Henri de Toulouse-Lautrec (1864–1901), Gauguin, and even Matisse.

We can see this in the spheres of the oranges and the mandarins in which the vermilion and carmine have been applied alternately with yellow, especially cadmium yellow, but also lemon yellow. There are also some touches of white. It is a painting that has been created by way of color, but it is not totally flat. "Its volume will be increased a little by its dryness. But *alla prima* there's a danger of dirtying it."

So as not to make the outlines of the objects hard, in this case the orange, she blends the background around the outlines with several brushstrokes. The fruit bowls will remain a soft luminous area of the background that will highlight the fruit inside them.

"I'm changing the apples' colors. I want them to be greener, not yellow as they are in reality, because there's already a predominating yellow in the painting, and the apples would come out too pale. I don't want them to be red either, because I already have that range in the oranges and mandarins. The green will create contrast and will prevent excessive monotony."

At this point the painter decides to leave the painting exactly as it is and give it the final touches when it is dry in two or three days.

83

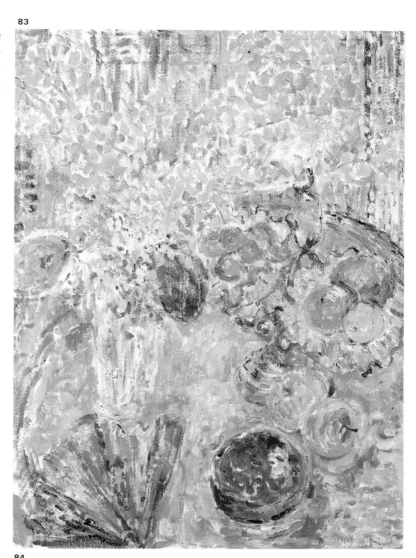

84

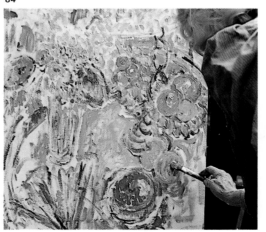

Figs. 83 and 84. Painting *alla prima* requires special preparation and practice. With a wet canvas you must take great care not to remove the color underneath, or, what would be more serious, mix the new paint with the previous colors. For this reason Diogène goes over the picture as if she were caressing it, applying soft brushstrokes in order to accentuate the feeling of relief while at the same time stumping the part of the background nearest the fruit.

Final Stage: Going Over the Dried Painting

Let's study the changes that Mercè Diogène has applied to the painting. First look at the background. It is quite "full," but there are also some short, gray (almost black) strokes in the right-hand corner that contribute to the yellow forsythia's positioning in the background. In the central part of those same flowers, she has applied a light-gray shadow grounding them and adding consistency. Down below, the white flowers are now emphasized and the mauve color has gained territory at the cost of the green leaves. The vase is now more profiled, which makes the flowers within it sit on a firmer base.

The oranges, mandarins, and apples have gained volume, they are more spherical with the more compact color that Diogène has painted in them, making them more defined and giving the background more emphasis. This is definitely the case with the oranges and mandarins in the opal fruit bowls. Here, more white has intervened and the bowls

are lighter. The painter had foreseen all of this.

In the bottom right-hand corner, under the apples, the predominant earthy mauve and yellow have been substituted in greater part by a range of blue-grays that balance and give life to this section of the painting. The fan has also had several modifications: the red has disappeared in favor of violet and the orange color has more depth. On the other hand, the little porcelain box is exactly as it was: the painter said she did not want to touch it, and she kept her word.

With her light but precise work on the dried painting, Mercè Diogène has given greater solidness and definition to the painting without removing the air of lightness that gives it so much character and constitutes its charm.

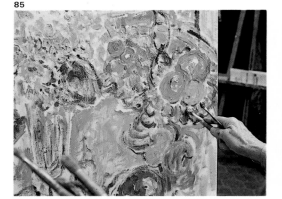

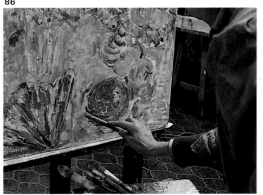

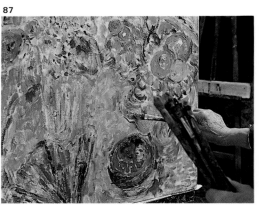

Figs. 85 to 89. After a few days, now that the painting has dried, the artist confronts it again in order to start on the details and modifications. With a wet painting this would have been impossible because of the risk of dirtying the previous colors. Of course, the painting will not lose any of the freshness and spontaneity Diogène achieved in the first session. In the first place, the artist has waited for the painting to dry to correct the background, because the violet used in the first session does not highlight the yellow flowers in the upper middle part of the picture. Also, the mauve flowers sticking out of the vase have gained central visual importance because the artist has toned down the green of the surrounding leaves.

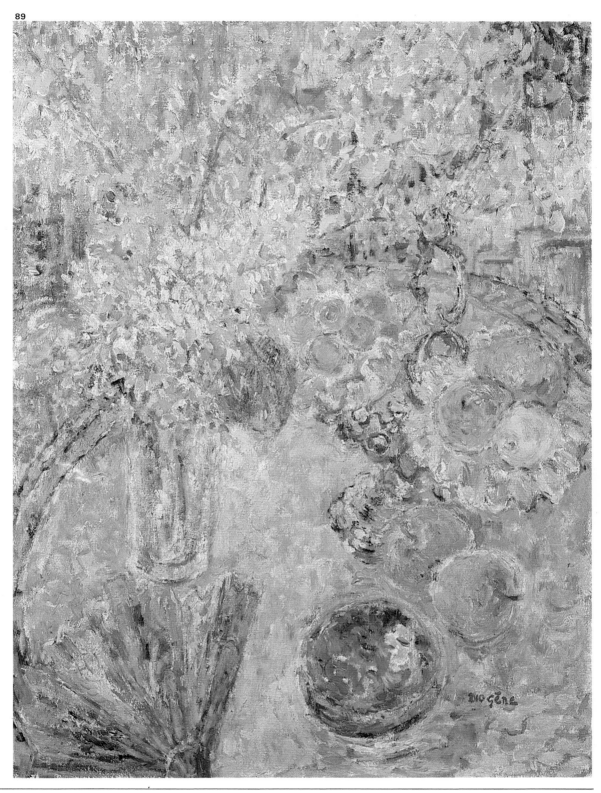

89

A Blue Still Life

90

Rafael Durán is a painter who was born in 1931. He has works in Los Angeles and has won prizes in Paris, but what is interesting to us here is that he was awarded a prize by the Royal Artistic Circle of Barcelona for a work titled *Still Life of Flowers and Fruit*.

And that is exactly what he is going to do for us now. From the very start he tells us that his way of working is decided by the theme itself: "There are painters who start by drawing, others begin staining; I proceed in one way or another according to what the subject requires."

The painter's studio is a large room, facing northeast. Filtered light penetrates through several blinds. At present Durán is preparing for an exhibition.

A Question of Colors

He also lets the setup inspire him in his choice of colors, although he confesses his preference for blue, which is ever present in his works.

Regarding the background color, it is always determined in accordance with the colors of the elements that constitute the still life in question. In this case the real background will be white: it is an unused canvas that he has placed behind the setup.

The objects have been placed on white: a white slab of marble, streaked with gray, from the top of an old chest of drawers.

The setup is made up of some flowers that the painter's wife has just brought in, some other flowers in a pot, three pears, three lemons, and an apple. There are two flower containers in the center, the flowers in the upper part, and the fruit in the lower part. The painter places the canvas in a vertical position. It has been prepared with a neutral, although warm background that has been very diluted with turpentine to help the painter harmonize his work from the beginning. Durán does not like to start painting over the white of the canvas.

Fig. 90. Rafael Durán has had exhibitions in many cities, including Los Angeles and Paris. He also holds an award from the Royal Artistic Circle of Barcelona, which was given to him for a still life.

Figs. 91 and 92. Durán is going to use this outdoor easel that holds the canvas he will paint on. The canvas was previously prepared with a very diluted gray background. Inside the studio Durán has lowered the blinds, because he does not like direct light; he prefers a softer, filtered light that will not influence the colors.

91

92

Durán's Works

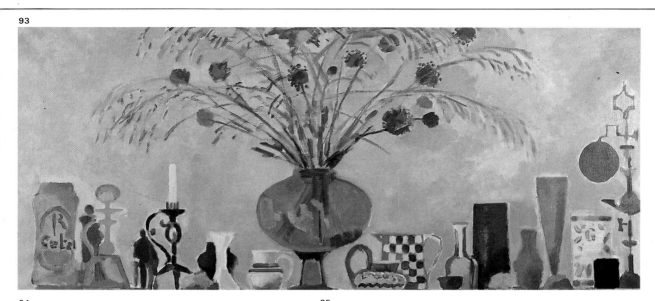

93

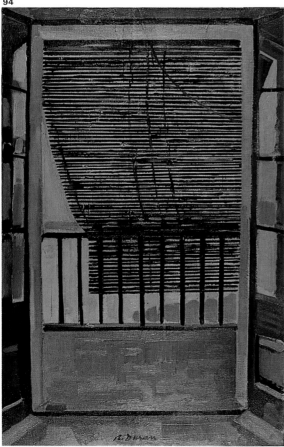

94

95

Figs. 93 to 95. A brief sampling of Rafael Durán's work. In the still life reproduced on this page, the artist opts for a frieze composition that allows him to include flowers in the entire top part of the picture.

Composition on the First Attempt

The painter did not think before distributing the painting's elements. Without any trials, Durán quickly put them into place. Even so, his chosen composition is both alive and balanced with the elements lightly counterbalancing one another in the lower part, and with the fruit distributed almost at random, very dispersed, over the surface on which they are placed. It has been done very quickly, but many years of experience are behind it. As some painters say: "Two hours to paint and twenty behind those two."

96

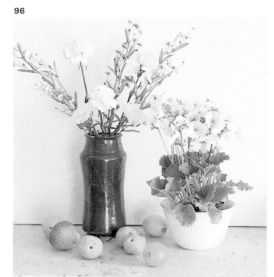

Fig. 96. The composition is the fundamental element of a still life. However, a painter's own experience shows when he instinctively moves the objects around in a space, following, without realizing it, the rules of compensation and balance that form part of our visual culture. In a few seconds, Durán has placed the elements of his still life to form two diagonals.

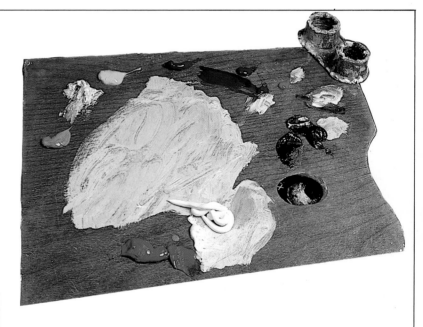

Durán's Palette

The colors used by Durán as well as their distribution reflect an outstanding personality. Few but basic colors—primaries, such as yellow, madder carmine, and ultramarine blue, the three colors with which all of nature's colors can be composed—and three more colors of the second order, but also basic: ochre, red, and green.

There seems to be no established order to the distribution of these colors on his palette, which confirms what was said earlier. This is his palette, his colors:

> ochre
> cadmium yellow
> carmine madder
> English red
> cadmium red light
> emerald green
> ultramarine blue
> white (in the center)

In one of the pots there is turpentine, and in the other, medium, which the painter considers excellent. "It makes the picture dry faster," comments the painter. "I mean, you can work in successive sessions on the dry painting, with the appearance of a fresh painting. It also gives a very agreeable pastiness at the time of painting."

First Stage: Lines and Stains

Durán begins to stain his picture with a fairly thick, well-used bristle brush. "A hard, worn brush," he says "moves over the canvas rather like a pencil." He uses the very same brush to measure the proportions between the objects.

He starts to sketch without very many hesitations with very little paint on the brush: forms, profiles, all of it rather pale, with a mixture in which blue is the predominating color. The painter makes the first decisions while the picture is still in the sketch stage. For example, he says: "The vase on the left, which is cobalt blue tending to violet, is very beautiful, but it's too tall." So that the composition breathes better in the top part, he decides to reduce the vase's proportion within the whole.

The first stain is applied, the first white stain on a neutral background, one of the carnations. Next Durán starts marking in green—combining several greens—the leaves and stems. Also with green, he paints a line separating the vertical part of the background with the horizontal surface of the lower part. Meanwhile, the painter says he likes Matisse very much, something you may have already deduced after seeing the open doors with Persian blinds (Fig. 94) painted a long time ago.

At this point, the composition's counterbalance has been established, and certain colorist elements with the variant greens of the leaves, above all, are seen in the smaller pot. The day has darkened. The painter opens one of the blinds.

Figs. 97 to 99. Rafael Durán has begun outlining —painting with large brushstrokes and using a very worn brush that allows him to sketch without preoccupation with light strokes. The artist is staining the colors of one of the carnations (fig. 97). At the same time he applies the green of the leaves and stems, he paints a line placing the still life in space (fig. 98): the painting's vertical and horizontal dimensions.

97

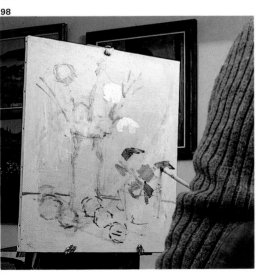

98

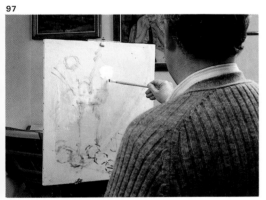

99

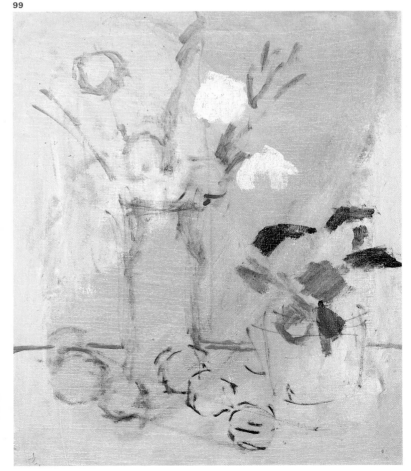

Second Stage: The Blue Vase and the Background

The painter is working in all parts of the painting at the same time. He alternates the outlines (the drawing) with the stains (the painting). For the first time he applies the carmine, which is mixed with white.

And now with great decision—from the beginning he has not changed his brush—Durán stains the blue vase, constructing the form and color at the same time. He cleans the brush with a rag and changes it for another one. Using this new brush, somewhat thicker than the former one, he mixes blue with great quantities of white to get a pale blue-gray that he uses to stain the background.

The blue vase constitutes what we might call the principal stain or color of this painting: we could now give it a title. Apart from the volume, note the reflection that has been achieved by way of simply not painting in certain areas—it allows the background to breathe.

Durán starts work on the background again and produces a warmer mix by introducing cadmium red. See how the background is not uniform, but is composed of a number of various grays: in some areas it is very blue, in others green, and in others red. The background color again outlines the blue vase's form.

Durán brushes in all directions. In his longing to fill the canvas he tells the story of a painter who applied all his brushstrokes diagonally to the right, and then one or two to the left so as to compensate for this. Or the other painter who did this in reverse and whose compositions *fell*. Has it not been said so many times that El Greco's (1541–1614) extended figures were a consequence of a defect in his vision? Personality develops from one's own defects, says Durán, remembering an idea attributed to Jean Cocteau (1889–1963). And some convert their limitations into style.

While he was saying all of this, the painter completed the background. Now that it is finished, and the vase constructed and some leaves and flowers outlined, the rest can be done.

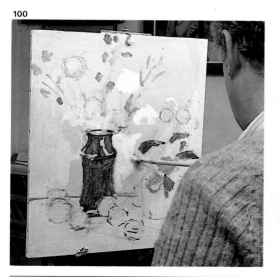

100

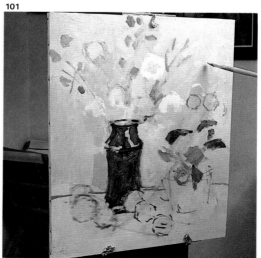

101

Figs. 100 and 101. Durán has changed the old brush that he has been using on the background from the beginning for another thicker one. He is going to profile the still life's elements by filling the canvas with color to outline the objects' forms. This phase is finished almost exclusively this way, except for some color touches to the flowers and leaves, as well as some large stains on the background.

102

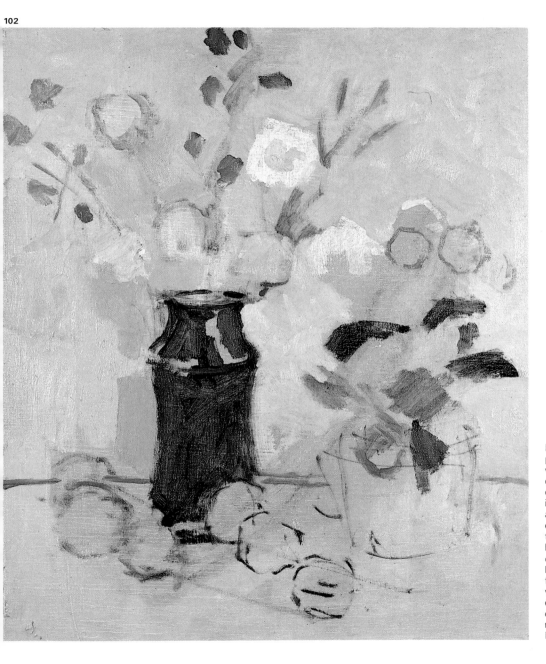

Fig. 102. Rafael Durán has painted the blue vase, which is the painting's dominant subject. He could now give the painting a title. He has painted a background that is not exactly uniform, but contains a range of grays with blue, green, and red tendencies. The background has outlined the vase's forms. ''There are two ways of constructing an object: filling it with color or outlining it with the surrounding color,'' says Durán.

Third Stage: Fast and Slow Painters

Now he commences to stain color values: the shadow of the white pot in the foreground and the lemon in the pot's shadow.

Durán speaks favorably about the experience of spectators, with whom he sometimes has short conversations, and remembers the situation in Gustave Courbet's (1819–1877) studio, in which some real get-togethers took place while the painter went about his work. "Of course, being alone," he continues after reflecting a little, "is very convenient for creating. The danger of working with people is lack of concentration. There's a real chance of getting distracted."

Durán distances himself from the picture to examine it, and he is quite satisfied. For the moment he likes the setup more than the painting.

"What is normal," continues the painter changing from poetic theory to technical prose, "is to start with the dark parts, and the light ones will come just at the end." The artist suspects that these will be the central carnation and the lemon in the foreground.

In the lower part of the painting, Durán takes great liberty in color choice in regard to reality. He applies a light violet where in reality there is a white tending to gray; this is a calculated decision: violet is a complementary color of yellow, and so between the lemons and their environment a strong contrasting harmony will be established.

The painter quotes Pierre-Auguste Renoir (1841-1919): "A painting must pass bad moments so as to be good." And then he himself adds: "The painting you have fought most with is sometimes your best painting."

Right away he thinks of van Gogh, who painted two pictures a day, and this leads him to say: "The speed with which a picture is painted has nothing to do with its quality. But of course, a bad painting that has been very carefully worked on tends to be worse than a bad one not so carefully worked on."

Once again, the painter finds himself in front of a picture whose harmonization is complete: the wide range of violets predominate and several different counterpoints have been hinted at.

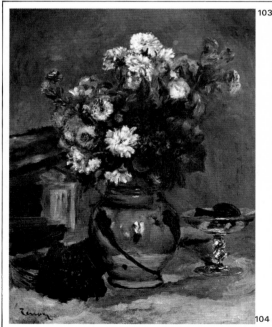
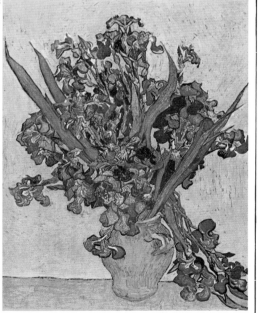

Figs. 103 and 104. Durán believes a good painting should look unfinished. Renoir thought that the best painter is one who went over his painting several times (fig. 103: *Vase of Flowers*. Louvre, Paris). Van Gogh (fig. 104: *Irises*. 1890. Rijksmuseum Vincent van Gogh, Amsterdam), however, painted two pictures a day. From this Durán deduces that painting a picture slowly or quickly has nothing to do with its quality.

105

Fig. 105. At this stage, Durán has resisted the temptation to apply light tones to the blue vase, or a luminous stain to the central carnation. He had these effects in mind, but prefers not to use them yet because the dark colors give the painting base and the light ones will come naturally at the end.

The painting is now complete with background and base. The painter begins to apply a certain color to a particular fruit—a dark touch of warm color in the shadow area of the apple. The same mix is used to define the ceramic flowerpot within the white pot. Durán very much wants to introduce lighter tones, but first he prefers to get something off his chest: "Clearly there's also a danger of conceptualizing too much; what I mean to say is not wanting to do what everyone else is. Sometimes the painter must paint how he likes, even if it's something very commonplace. You must enjoy painting."

When a Lemon Is Not a Lemon

Durán returns to the top part of the background. One of the advantages an artist has is that he or she can modify reality according to taste; normally it is a simplification, an elucidation of reality: "The color stains that constitute the object are more important than the form itself."

The painter takes up a spatula, mixes white with ultramarine blue and a little carmine, and produces a medium violet. The color is then deposited directly onto the canvas, and the artist proceeds to form the right-hand flowers. Afterward, he paints in the central part of each one of the flower's green pistils.

Using a fine brush, he begins to work on the stems of the flowers in the blue vase. Durán adds ultramarine blue to his mix and once more goes over that vase, which he has not touched in a while. He constructs volume, areas of shadow and light, as well as some highlights with the ultramarine blue. Using a rather fine brush, he introduces a sharp, white reflection, but then realizes it is very commonplace and with a sharp painting knife he proceeds to eliminate it totally. He neutralizes the highlight even more by passing his finger over it: "It's too pretty, too implacable," he concludes.

Now it is time to fill in that famous central carnation with white, which will become the brightest element in the picture. Durán applies mores white to the pot, a bone white, and says he will not do the vertical grooves, because like the highlight he just eliminated, they are too "pretty."

Why do painters include fruit in their still life paintings? "Because they have soft hues that are very often difficult to reproduce," he answers. And he encounters in the green of two opposing pears two distinct hues whose combination together makes him happy.

The painter isolates the yellow of the lemon on the extreme left with his finger, while saying he thinks he is doing something prohibited, because his masters told him never to use a finger to paint.

Now he outlines the base of certain elements with several dark grays: the apple, the lemon of the foreground, the white pot. "It's important," he says, "that the objects have a base. They mustn't float around the painting."

At last, what the painter has been waiting so long to do: he gives himself the great pleasure of painting the clean, luminous yellow of the lemon in the foreground, which will constitute the principal light source in the lower part of this painting.

"As Van Gogh said: 'When I paint a sunflower it is as if I were painting the sun.' The important thing for me at this moment is not that it be a lemon, but that it's precisely the type of yellow I want to apply to my painting. Now it's not a lemon, it's just the yellow of the painting."

Figs. 106 to 109. Now the artist employs different mediums to paint: with a spatula, he deposits color directly onto the bellflowers on the right; using a fine brush, he paints the stems of the flowers in the vase with violet and employs a painting knife to erase a highlight he had previously put on the vase, and then he shades it with his finger.

106

107

108

109

110

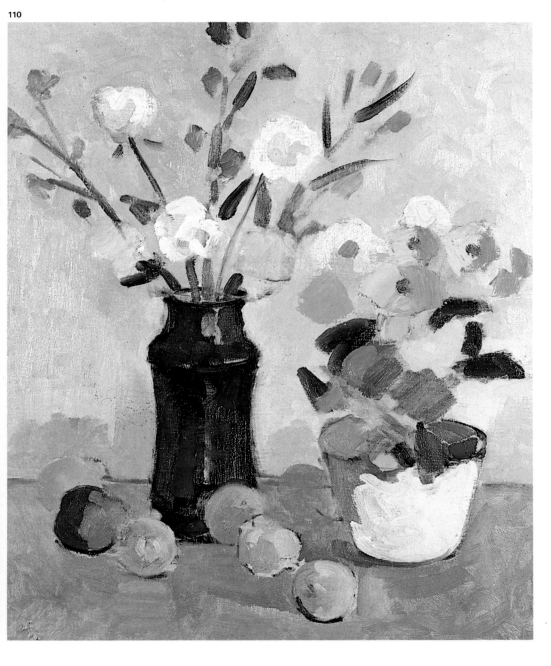

Fig. 110. The still life has volume. Durán has introduced light colors that since the last phase were seen as visual and luminous centers, above all in the central carnation and the pot on the right. The shadows have also been accentuated with dark grays that by contrast have given relief and volume.

Final Stage: The Essence of Atmosphere

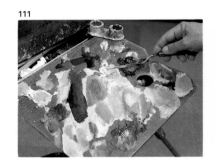

111

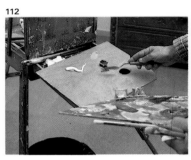

112

Durán begins to work on the shadows that are projected by the elements of his still life. Every time he uses his finger to retouch a detail—and he does it very seldom—he has the sensation that he has sinned and looks into the corner where posters of Pablo Picasso and Jan Vermeer are, as if he were asking for forgiveness. Although Durán's painting is not hyperrealistic, the painter worries about *explaining* in forms: the flower, the stem, the leaf—but in a synthetic mode. He quotes Picasso (1881–1973): "It's all very well to paint the buttons of a jersey with great thoroughness, but you must go with care because those buttons could easily jump out at you."

The shadows projected by the objects over the flat surface have given the composition relief, but they also give volume to the elements: "Some painters first finish one thing and then they go on to another: now I'm done with the carnation, let's go to the next one. I'm going from here to there, but I never lose sight of the painting as a whole."

Durán says the work of a perfectionist can be boring, not only for those who paint, but also for the viewer. Having said this he decides his palette is too dirty. He puts it aside and picks up a completely clean one, on which he begins to distribute new colors as if he were starting over. And in effect he *is* going to start: he will commence the final touches.

"Degas said, 'to paint a picture is to murder: it's necessary to have alibis.'"

A touch of white is added to the lemon in the foreground, which rounds its light. A bit of light violet-gray in the left part of the central carnation increases the white's luminosity. "The painting itself tells me where to go." The painter's work has slowed down, maybe because, as he himself says, this final part is the least interesting. What he likes is to not *finish* the painting too much.

"Some areas I want to leave exactly as they are, so that the painting will have an unfinished air about it. Painting is a form of elimination to a certain extent. If a leaf is present in reality, it doesn't mean to say

it must be in the painting. For example, this one leaning to the left I'm going to include it because it balances the diagonal ones on the right; on the other hand, I won't include this other one. The painter includes what he needs; what is obsolete is erased."

Now he is applying some light mauve onto the carnation on the right, where there had been a pink tone. And Durán stops and says: "The painting's finished."

He places it on the marble slab next to the setup, and steps away. "A painting can go through one or a hundred sessions. This had one. The essence of atmosphere exists in it, and that's what interests me, because I'm not a hyperrealistic painter."

And indeed he is not. Perhaps he is a descendant of the impressionists. "Yet," he admits with reservations, "there is a certain amount of naturalism in impressionism that I've never liked. I prefer Matisse."

113

Figs. 111 and 112. Even when it would be considered normal to use only one palette, which would be cleaned every now and then, Durán prefers to change his one palette, depositing new colors on it as if he were starting over.

Fig. 113. Whenever Durán retouches with his finger a shade or shine that might appear too academic, he cannot help looking at his posters of Picasso and Vermeer as if he were pleading for forgiveness.

Fig. 114. This is Durán's finished work. The painter maintained the painting as a whole in view for one single session and, as we can see, in each one of the phases he *painted everything at the same time.* In this last stage Durán's way of working is even more evident. In an exercise of constant creativity, it is not advisable to concentrate on *finishing* any particular element of the still life, such as the lemons, fruit, carnations, and so on. By applying a white reflection on the lemon in the foreground or a light gray to the central carnations and thus increasing the white's luminosity, the painting's color harmonization and finish will come together by themselves. Knowing when to stop so as not to lose the picture's freshness and spontaneity is very difficult (and very important).

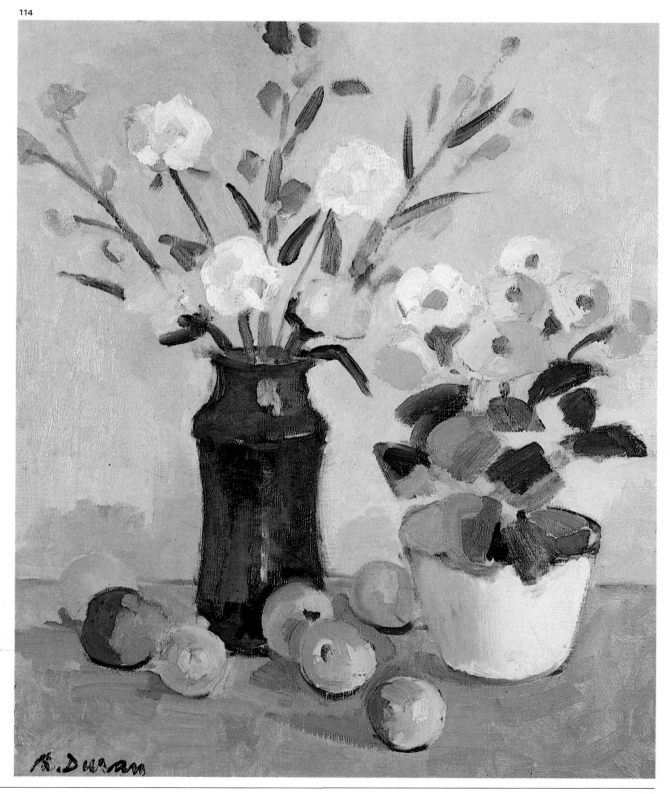

A Technique Older than Oil

Gabriel Portolés is a well-known painter. Since he turned professional in 1960, he has had many shows in permanent galleries in Chicago, Amsterdam, and Vienna. He was born in Jaca, Spain, in 1930, and mainly paints figure and still life pictures. Up to this point, his biography is similar to countless other painters. However, Gabriel Portolés is a *rara avis*.

He is a *rara avis* because he does not paint with oil, nor does he paint with watercolor, gouache, pastel, or acrylic paints. At the end of the twentieth century, Gabriel Portolés is painting in egg tempera.

Tempera with Egg Yolk

On the subject of tempera, the *Dictionary of Art and Artists* by Peter and Linda Murray says: "Pictorial technique that uses pigments to *blend* color in powder for use in painting. However, in practice, the main binding material employed is egg yolk; this was the principal technique till the end of the fifteenth century."

Just like the anonymous masters of the Middle Ages, so Portolés has been painting since he became a professional painter. And he paints on boards exactly as those medieval artists did. He orders his wooden boards of 2½ inches (1 cm) in thickness from a carpenter.

Then he gives them a coat of *gesso*, a mixture of Spanish white and glue that is applied to cover the canvas in several coats superimposed on one another. Then he rubs them down with sandpaper on the terrace of his studio, leaving them completely smooth and ready to be painted on.

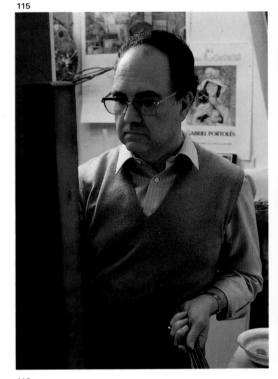

Fig. 115. Gabriel Portolés is a very unusual painter, not only for the intrinsic quality of his pictorial work, but also, and above all, for the technique he uses: painting in tempera with egg yolk, a technique used up to the fifteenth century, when oils became the main medium of painting.

Figs. 116 and 117. On a table in Portolés's small studio, among art books (indispensable in a painter's library) and a radio (music is a painter's ally), there are the pots and bottles containing his egg colors.

The Tempera Work of Portolés

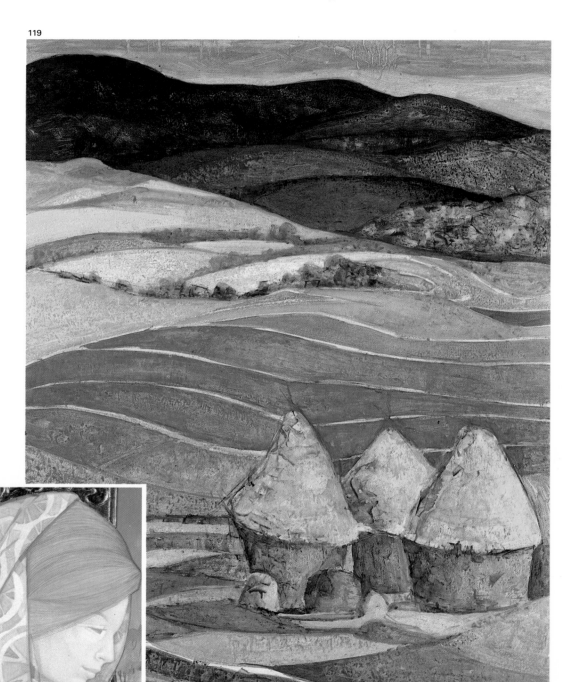

Figs. 118 and 119. Tempera with egg yolk, which is very similar to gouache, allows you to paint quite thickly or with great transparency, according to the amount of pigment diluted in the emulsion (see its preparation on page 55). Portolés prefers to work with very diluted colors, with which he obtains transparent coats, such as the green face in the detail reproduced in fig. 118, a very characteristic color of his work.

The Hard Work of Tempera Painting

In many ways Portolés does not differ very much from the medieval artisans previously mentioned. Shut up in his small studio, a $17\frac{1}{2} \times 26\frac{1}{2}$-foot ($4 \times 6$ m) room with two vertical windows facing northeast, Portolés paints his boards under a wooden pyramid. He believes that the pyramid captures cosmic energy and allows him to work better.

Gabriel Portolés works on several paintings at the same time. Some of them rest while he works on others, exactly as Titian did. The way his paintings progress makes it very difficult to calculate the amount of time it takes to complete each painting.

It is a laborious way of painting. Once the boards are prepared—not by the painter, but by a specialist in lacquers who prepares them according to the painter's instructions—a long process commences of creating the painting in egg tempera, which the artist makes up himself. However, the painter has various resources available so as to avoid making such a laborious process too mechanical.

But first things first. Now is the time to see how Portolés prepares his egg tempera.

Fig. 120. *Saint Lucas Painting the Virgin* (detail). A work by one of Quentin Massys's (c. 1465–1530) disciples. National Gallery, London.

Fig. 121. Giotto di Bondone (c. 1267–1337). *Meeting in the Áurea Door* (detail). The Scrovegni Chapel, Padua.

Fig. 122. Portolés paints under a wooden pyramid connected to his easel because he believes that cosmic energy converges there as he paints.

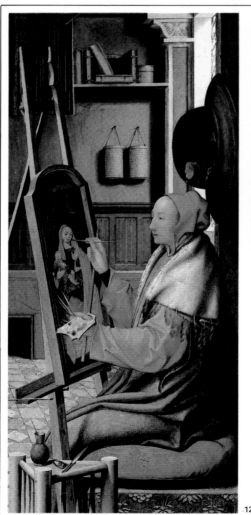

-120

121

122

Painting in tempera: predecessor of oil

Around the year 1410, a young painter named Jan van Eyck (1395–1441) discovered oil paints. Until that time, during the thirteenth and fourteenth centuries, artists painted in egg tempera. It was used to paint miniatures, illustrations, manuscripts and missals, icons, decorative panels, and murals.

Because of its similarity to oil, we included a picture painted with this technique in this step-by-step series by a specialist in this field: Portolés.

Egg Yolk, Varnish, Water, and Pigment: The Tempera Preparation

The traditional egg tempera technique, before oil was introduced in the fifteenth century, consisted of making a paste —a mix of pigment with water—and when it was time to paint, wetting the brush in the whisked egg (both white and yolk together). However, Portolés uses his own technique.

He mixes egg, varnish, and water into a paste. Once this paste is well mixed, he introduces powdered pigment and gets an even thicker paste, which he mixes as thoroughly as in the previous stage. He does this with every color he is going to use, and then pours each one of them into a separate pot, as if he were painting with gouache.

But Portolés uses gouache as complementary material, though he never uses it as his main material for painting. In his opinion, gouache is too opaque and covers too much. Egg tempera, on the other hand, permits great transparency; it allows the board to *breathe* through the paint. (See the woman's green, transparent skin in fig. 118).

Now Portolés shows us a sample of a concrete color preparation in egg tempera. Materials? A medium-size bottle, a glass, a smaller bottle of varnish, and a spatula.

He cracks the egg into the glass as if he were about to cook an omelet. Once whisked, he pours it into the bottle. Next he pours in a similar quantity of water and then the varnish, and shakes the bottle almost as if making a martini.

123

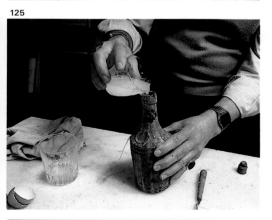

124

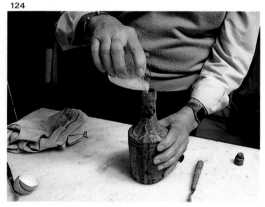

125

126

Figs. 123 to 126. In order to obtain the colors traditionally used when painting in tempera with egg yolk, first a paste is prepared— pigment and water—and when ready to paint, the brush is dipped in the whisked egg. Portolés uses a somewhat different technique that allows him to make several colors and conserve them in pots. First he whisks an egg in a glass and then pours it into a bottle. He then adds water and, lastly, the varnish. The pigment is spread out on a marble surface and a small quantity of the liquid is poured over it. He then mixes it to remove any lumps. It is now ready to be put into containers. In this way he can prepare the colors as he needs them for several sessions.

Drawing on Paper

Portolés takes some blue pigment and with his spatula spreads it over the marble surface. He pours out the top part of the mixture and it starts to bind, much in the way that cement mixes with water. He continues to stir until all the lumps have disappeared... and that's it: the ultramarine blue egg is served. (See figs. 123 through 126 on page 55.)

When the paste's consistency is satisfactory, he pours it into a pot. And he goes on to do the same with each one of the other colors he will use in the painting. Portolés can use it for up to a week—but not longer—because the egg starts to rot and the preparation, leaving aside the bad smell, becomes totally useless.

The Drawing

Protected by the pyramid—with one of its sides facing north as is traditionally mandatory—the artist will now demonstrate his work process. He uses ordinary oil paintbrushes and tends to work in the afternoon, nearly always under artificial lighting conditions. Since his studio faces northeast, he never receives direct sunlight. He very often uses his imagination when painting still lifes and figures. Sometimes he uses elements from previously painted pictures. For example, in the still life whose process we are seeing now—a jar, some sunflowers, some apples—Portolés says, "I don't need an apple in front of me to paint one." First he does the drawing on paper. He sketches out the fundamental forms with sweeping strokes and immediately the still life's outlines appear: an empty jar, another one with sunflowers in it, and two apples.

Even some of the shadows have been hinted at: this helps Portolés in his first try at the light and shadow areas, even though when the drawing is transferred onto the board it will only benefit from the outlines.

127

128

129

Figs. 127 to 129. Standing under his cosmic pyramid, Portolés first makes a very detailed drawing on paper. He then sketches some shadows, although when it is transferred onto the board (figs. 130 and 131), only the outline will be traced.

Tracing the Sketch onto the Board

Transferring or Sketching

In order to sketch this drawing onto the board, Portolés uses wrapping paper impregnated with blue powder (the same pigment he used for his tempera mix). Placing the drawing on top, he starts going over the outlines. The lines will be marked on the board by the blue pigment.

The goal of this operation is to obtain a completely clean drawing on the board. Then using the same blue pigment, this time diluted with water, he again goes over the drawing that is on the board. He also uses the blue to indicate several color masses, but very few shadows. The background is where this artist normally starts. Since tempera in egg yolk dries very quickly, he can work very quickly if he so wishes. But as we already said, Portolés works without haste. At this point we can consider phase one complete.

Portolés's Palette

Portolés establishes his palette on a marble table. You can see most of his colors at the bottom of this page. He uses:

ultramarine blue
violet
vermilion
sienna
lemon yellow
cadmium yellow medium
white
emerald green
turquoise blue
yellow ochre

He wets these colors with water so they do not dry while he works. To the left of the table, there are pieces of sponge and a small water pot, as well as a jar of brushes.

Figs. 130 and 131. Using wrapping paper impregnated with blue pigment, Portolés goes over the drawing's outlines that will remain traced onto the board.

Fig. 132. Portolés's "palette" is a marble table. He spreads his previously prepared colors over it. He adds water just before painting.

First Stage: A Blue Drawing

After having outlined the forms in blue, Portolés stains the board with the other colors, always starting with the background as is customary, and using the sponge to absorb the excess color.

The painting is becoming, to a certain extent, a "negative" in which the backgrounds already have color while the objects in the foreground are still white.

Portolés uses just two brushes for this operation: a number 12 for the cool tones and a number 18 for the warm ones.

With the painting still in the previously mentioned state, Portolés starts to paint the yellow of the sunflowers. This gives him a general idea about the color distribution of the picture.

Figs. 133 to 136. His first step is to sketch the setup in blue (fig. 133). Portolés then paints the background using oil paintbrushes and a sponge for absorbing excess color. Afterward he paints the yellow sunflowers. The painting's colors have now been determined.

134

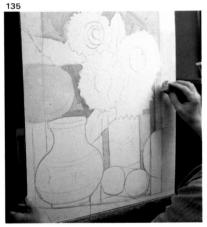

135

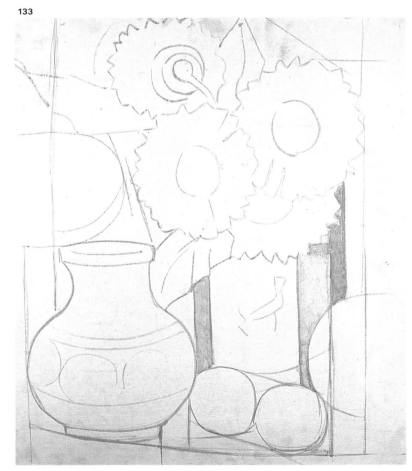

133

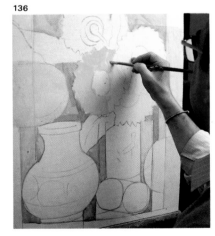

136

Second Stage: Starting with the Background

137

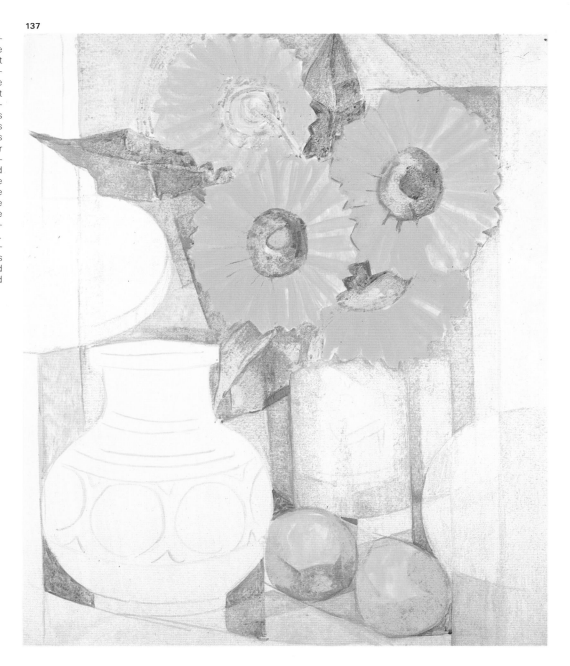

Fig. 137. The fact that Portolés starts by painting the background saves him a lot of headaches. He establishes different tones in the painting's more important areas from the very beginning. Painting the elements before the background is more dangerous. This is due to the fact that a color is lighter or darker according to the background color surrounding it. If the object is painted first on the white of the canvas, the object's color can later be altered when color is applied to the background. Furthermore, when finishing this phase, Portolés has colored the sunflowers and sketched some lights and shadows.

At the end of this stage we see the painting lacks relief, shadows, and other elements that Portolés will include as he paints. There is only the color of the cylindrical jar; the spherical one in the foreground in still without color. The light areas are now being included in the apples and sunflowers that will confirm their volume. See how the two apples differ in color: yellow predominates in one and red tones in the other. He is also painting in the green leaves of the sunflowers.

Third Stage: Sponge and Brush

Portolés starts to work on the blue cylindrical jar on the right, filling in the details of the ceramic decoration. He is establishing the painting's main light area and the shadows cast by the sunflowers from above.

He undertakes the decoration of geometric figures in the right-hand jar (in earth tones on an almost white background, for now). Even though the egg tempera dries rapidly, it is better not to paint over wet if a clean stroke is desired.

See how he works on the jar with two different browns, not only in tone, but because one contains more yellow ochre and the other more carmine. And from this combination of the two color values the artist obtains the balance in the foreground of this 12 format composition.

Portolés affirms that it is different to work on a figure or landscape format, whatever the subject may be. It is the theme that indicates the best format. He is now constantly alternating the brush with the sponge. The painting has reached an advanced stage in which the main characteristics of color harmony have been determined. But it is still a harmonization of lesser tones, and it still lacks relief, depth, and the tones that will be present in the final picture. Portolés is now beginning the dark shades.

You may see that the character of this still life is basically impressionistic. "I consider myself an impressionist," the painter says.

Fig. 138. Our artist has painted the blue jar. After having established the shadows projected by the sunflowers and painting the jar's drawings with a fine brush, he continues to work using a sponge to absorb color.

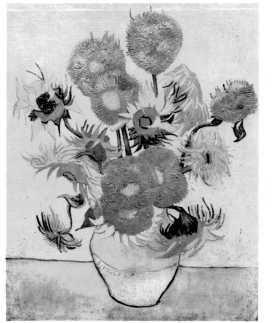

Fig. 139. Gabriel Portolés has a preference for flat colors because he believes that volume can be obtained from color. What is more, color *is* volume. The *colorist* conception of painting has a master: van Gogh. His painting *Sunflowers* is a good example of it. In order to find out more about this painting, van Gogh, and still life paintings in general, turn to pages 4 and 5 in this book.

Fig. 140. At the end of this stage, Portolés has resolved the foreground. He has used two different browns on the ceramic pot, not only different because one is lighter than the other, but also because of the composition—one has more ochre and the other more carmine—with which he has hinted at the pot's spherical shape and has harmonized it with tonal value of the picture and background colors. We can now see Portolés's impressionist influences in the elements and the cubist influences in the background.

Fourth and Final Stage: Style

141

142

143

The painter is looking for qualities through the small details here and there. In this almost organic painting, as in nature, nothing changes; everything transforms. It is a slow and meticulous process, coat after coat, transparency over transparency, brush to sponge and then sponge followed by brush, day after day until the picture acquires its definitive features.

Each one of the elements that makes up the still life is a progressive enricher: the blue motifs on the jar containing the sunflowers; the white light of the center; the soft blue around the edges. "I'm not searching for strict realism in the shadows and lights, but only a subjective aesthetic effect. I'm not compromised in producing anything, I'm just making artistic decisions."

He goes back to work on the blue jar. He works as if he were the ceramist who decorates the jar, but at the same time he resolves the problem of volume. Portolés works calmly but with energy, taking up the sponge and removing the excess color. At certain points he uses a very fine brush for outlines and the small details of the jar's decoration.

Portolés now reinforces and gives relief to the sunflowers' green leaves. It is a different green from that of the jar in the foreground. He has isolated each of the yellow petals of the sunflowers. These flowers have light, shade, and volume, just like the jars and apples.

But arbitrary shadow do not always take light direction into account so strictly. Generally, light comes from one of the sides. Portolés is not worried about the logical realism of light and shadow; he is only interested in the pictorial effect he wants to produce: "What I want to do is transmit a feeling, and I don't care if I communicate that feeling by decorative means. A painting, at the end of the day, is a decorative element; there's no need to think of it pejoratively. It doesn't mean I paint decorativist art."

We said that cubism and impressionism were present in Portolés's painting. "I use cubism in the background," the artist says. Cézanne is also present in this painter, not only for his way of resolving the two apples (see how spherical they are now compared to the previous stage), or for his unitary treatment of chromatic and tonal values, but also for his meticulous slowness in working.

He is not only concentrating on the foreground objects—the sphere-shaped jar of warm tones, for example—but returns to the background time and time again, and in this way the painting acquires its definitive relief, not to a determined point, but only when the painter decides it has been reached.

Portolés is conscious of being a painter with style. His paintings are unique, not only for their technique, but for the type of stylistic resolution that such a technique permits.

Figs. 141 to 143. As if he were an artisan, Portolés paints in the pot's decoration and thus accentuates the pot's spherical shape. The shine and shadows that he incorporates also contribute to this effect, most of which are not real, but have been *invented* by the painter to accentuate the spherical shapes of the apples.

Fig. 144. This is an authentic colorist still life. While Portolés was painting his picture, he had van Gogh's sunflower theme in mind. So in the final critical evaluation of the painting, we must note the preeminence of color, which by itself constructs shapes and creates volumes, without having to add shadows or real valuist lights. The artist has painted only what he thought necessary. For this reason he toned down the green of the sunflowers' leaves. The same was done to the apples and the pot of the foreground, but all these shadows are colorist—that is, they do not come from real valuist lights and shadows.

144

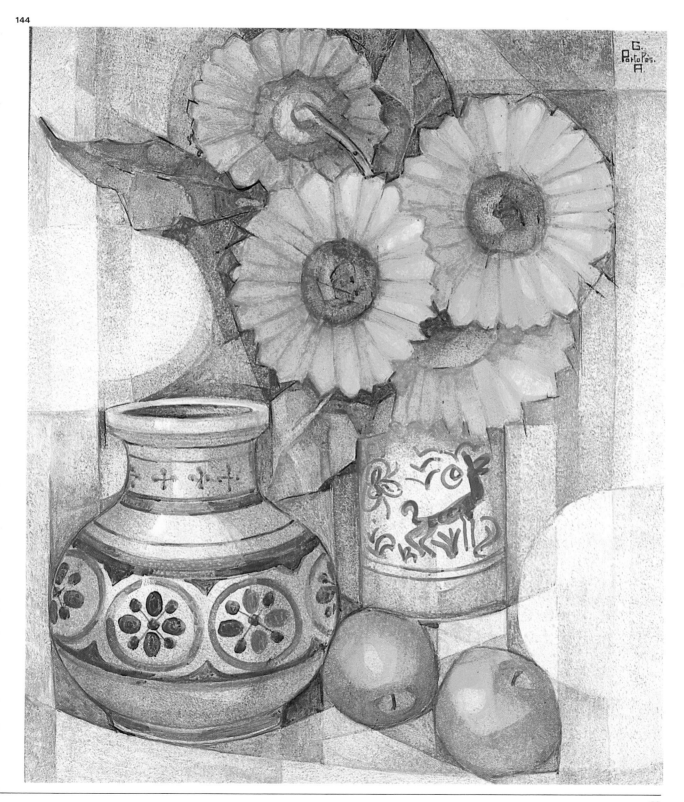

Contents